Liverpool Chara and Streets

The Photographs of C.F. Inston

Published by The Bluecoat Press, Liverpool
Book design by Michael March, Liverpool
Printed by Tenon and Polert Colour Scanning Ltd.

ISBN 9781904438908

Acknowledgements
The author wishes to acknowledge the great help given to him by the late Joseph Hepple Williams, past-archivist of Liverpool Amateur Photographic Association (LAPA), and to the ever-helpful staff at Liverpool Record Office. The photographs were copied from a set of lantern slides in the possession of LAPA and an album of contact prints in Liverpool Record Office. The portrait of Inston and the three exhibition prints were all from the Permanent Collection of the Royal Photographic Society (courtesy of the Science and Society Picture Library).

Photographers of Liverpool Series: Volume 4
The Bluecoat Press is publishing a landmark series of titles concerned with the way photographers have interpreted the people and cityscape of Liverpool. There is an impressive number of photographs in collections, private and public, which contribute substantially to our understanding of the growth and shape of the city and each volume in this series will reproduce images from these important archives.

Liverpool Characters and Streets

The Photographs of C.F. Inston

Colin Wilkinson

THE BLUECOAT PRESS

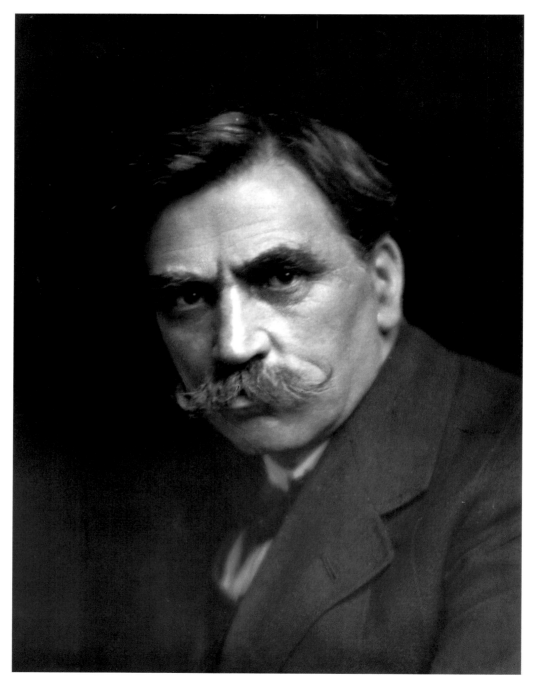

Charles Frederick Inston by John Smith of Liverpool.

INTRODUCTION

Thirty years ago, back in 1979, I curated a photographic show on the work of Charles Frederick Inston at Liverpool's Open Eye Gallery. My intention at the time was to stage a series of exhibitions on the work of local photographers and my initial research had thrown up a small number of possible names.

A trawl through the archives of Liverpool Record Office revealed a small album of contact prints by Inston entitled *Liverpool Characters and Streets about 1890*. Fascinated by this glimpse into the city's street life at the end of the nineteenth century, I began a slow process of research into Inston's life and finally selected enough images for a small exhibition. Limited in scope, it was centred on copy prints obtained from a set of lantern slides in the possession of Liverpool Amateur Photographic Association (LAPA) supplemented by prints copied from *Liverpool Characters and Streets*. At that time, apart from a small number of exhibition prints held in the Royal Photographic Society's archives, there was little evidence that any original Inston photographs had survived.

With little more than his name and his membership of LAPA, I gradually pieced together a patchwork of facts about his life. Ironically, it was his death and subsequent obituaries which provided the richest seam of information. What emerged was that Inston, during his lifetime, was internationally recognised and is one of the most important photographers Liverpool has produced. Approaching a century after his death, it is time he was reassessed and this book is a belated recognition of his contribution to photography.

LIVERPOOL AND PHOTOGRAPHY

As one of the great world cities of the nineteenth century, it might be expected that Liverpool was at the centre of photographic culture. However, although Liverpool was awarded one of the first commercial licences for the Daguerrotype process in 1841, its wider use was seriously hindered by the patent rights surrounding both Daguerre's positive process of 1839 (from which copies could not be made) and Henry Fox Talbot's calotype process (patented in 1841), which produced a negative from which any number of prints could be made. The latter process held a greater attraction for amateurs but its use was restricted by Fox Talbot (as with the Daguerrotype process) to those prepared to pay a licence fee.

It took the invention of the collodion wet plate by Frederick Scott Archer in 1851, which was not patented, to create the impetus for a wider use, particularly after 1855 when Fox Talbot's patent expired.

Although still a pastime for the wealthy, photography began to be practised by a greater number of amateurs. The formation of photographic societies, where experience and knowledge could be shared, played an important role in the widening of the franchise of photography – a movement that reached its pinnacle in the years leading up to the First World War. Leeds was the first society founded in 1852, followed by London in 1853. Liverpool Photographic Society became the third, two months after London, and started with seven initial members, including James Newland (the Borough Engineer), Francis Frith (a wholesale grocer in Lord Street, who sold his business in 1855 to further a career in photography, becoming one of the foremost topographical photographers of the nineteenth century), C.H. Chadburn (a lens maker), James Forrest (whose firm sold glass, including glass plates cut to photographic size) and George Berry (a professional photographer).

The society quickly grew and within a year reached 120 members. It launched its own magazine, *Liverpool Photographic Journal* printed by Henry Greenwood of Canning Place, in January 1854. In 1860, Greenwood moved to London, taking the magazine with him. Renamed *The British Journal of Photography*, it is the oldest photographic journal in the world still in existence.

After its early years of success, its fortunes changed and, faced with dwindling

The first, pioneering photographers were handicapped by having to take everything with them, including a portable darkroom for preparing and developing glass plates *in situ*. Francis Frith, who sold his Liverpool-based wholesale grocery business to fund his interest in photography, made his name with stunning images of Egypt and Sinai. His journal elaborated on the difficulties of the trip, commenting on the 'smothering little tent' and the heat being so intense that the chemicals boiled up over the glass.

financial resources and shrinking membership, Liverpool Photographic Society ceased to exist in 1859. In 1863, after a four year abeyance, former members reformed the society as Liverpool Amateur Photographic Association (LAPA). LAPA witnessed steady growth but, by 1878, membership was only 63. Photography was an expensive hobby and the technical limitations of the medium restricted a wider involvement. One of the key problems was slowness of exposure, necessitating using a tripod to avoid blurring the image. The weight of glass plates, with their wooden film holders, the camera itself and a tripod, made photography a cumbersome pursuit, as LAPA minutes record:

The new President in 1884, Dr Kenyon, in his inaugural address, made a plea for the tricycle as a means of getting about and carrying photographic apparatus. He said that in 1879 he made a journey into the heart of Wales on a 'Salvo' tricycle with a 7 x 5 camera, stand, plates and a knapsack, the whole weighing about thirty pounds, while on the one he had then, a 'Humber', he could comfortably carry a 12 x 10 camera, half a dozen plates and a stand.

A long way to go for six exposures but technology was about to change everything. The first hand-held cameras were introduced in the 1880s, making tripods, once indispensable, no longer essential, allowing greater manoeuvrability. The replacement of glass by celluloid roll film had an equally dramatic impact, creating the opening for a mass market for photography.

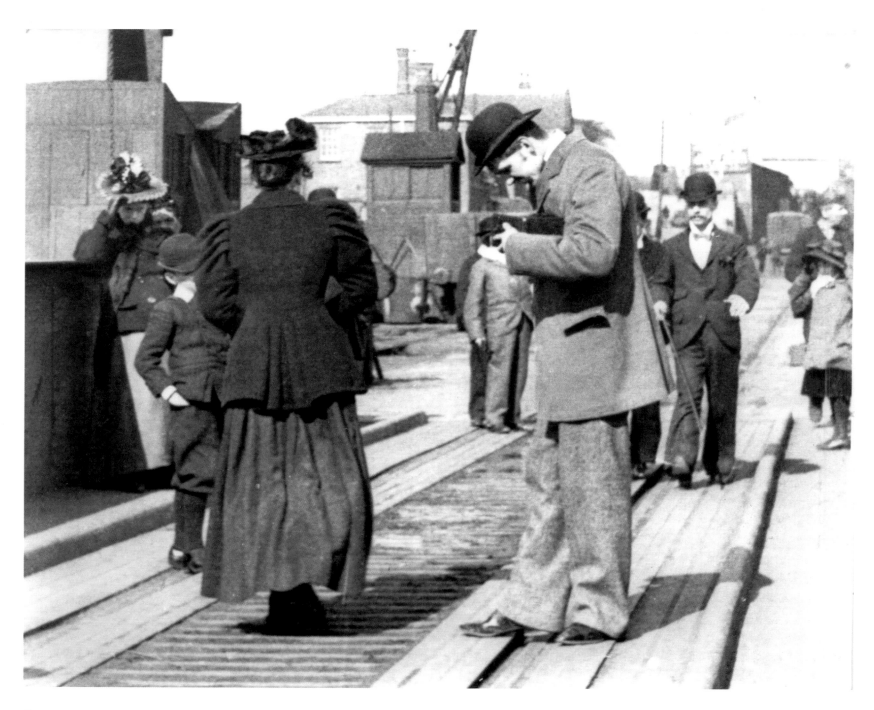

YOU PUSH THE BUTTON – WE DO THE REST

In 1888 George Eastman introduced a camera which incorporated roll-film as an integral part. Calling his new camera The Kodak – he was to revolutionise photography. *'You push the button – we do the rest.'* A Kodak loaded with enough film for 100 photos was returned for processing and printing. It did not come cheap; at two guineas (£2.10), it was more than a week's wages for the average man. Eastman's was not the first roll-film camera, there had been earlier versions, but the real significance was the developing and printing service, which removed the need for a darkroom and all that that entailed in terms of time, space and knowledge.

The first plastic – celluloid, was invented by John W. Hyatt in 1869. Light, tough and transparent, its application to photography was immediately apparent, but it was too thick and streaky to replace glass. By 1889 Henry Reichenback, Eastman's chemist, had succeeded in making celluloid thin and flexible enough to be used in rolls – the first commercially produced transparent roll film. By 1891 all the elements existed to transform photography into a truly popular activity: an easy to use camera, celluloid roll film and a professional developing and printing service.

Increasing leisure time and money meant there was a vast new market for photography and Eastman introduced a series of cameras that could be loaded in subdued light, in particular the Pocket Kodak camera in 1895.

It is aptly termed 'Pocket Kodak', for it is just one of those natty little things that a photographer would particularly desire to put in his pocket. Practical Photographer.

The first batch sold out in days with 100,000 selling in the first year. Eastman followed the Pocket Kodak with the Folding Pocket Camera in 1897. Its picture size (8 x 5.5cm) was over twice that of the earlier camera. A milestone in camera design, it pioneered a whole generation of popular folding cameras.

The Hand Camera has made great headway in general use during the past year, and it is surprising to note that, aside from its utility in giving hundreds and thousands of people a ready means of indulging in photography as a pastime, how very serviceable it has become for more serious purposes. As an adjunct to presswork, it has become indispensable. British Journal of Photography (1894).

Mann Island c1895. An amateur photographer takes a candid family photograph with a hand-held camera. (Photographer unknown).

Three members of Liverpool Camera Club on their weekly outing in 1892. The small camera on the wall is possibly a Kodak No 2, which was introduced in 1889.

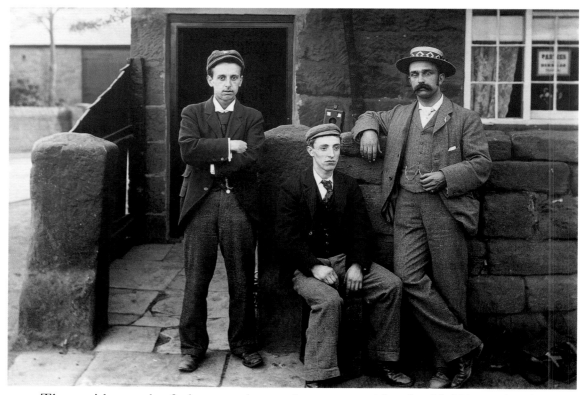

The rapid growth of photography can be measured by the 25,000 entries for an international exhibition of amateur photographs held in London in 1897. However, photography, although much simplified, still remained relatively expensive and Eastman was determined to extend its appeal.

For the further growth of our business and profit, we look to make Kodakers of every school boy and girl and every wage-earning man and woman the world over. (1899)

The introduction of the Brownie in 1900 for five shillings (25p) was to revolutionise the use of photography. Popular photography had been born.

It is against this background of rapid technical advances and the breakthrough of photography as a mass consumer activity that the career of Charles Frederick Inston must be viewed.

CHARLES FREDERICK INSTON

The greatest problem in writing about Inston is that he left no account of his life. This is not unusual but it leaves significant gaps in what we know about the man. What we do have are obituaries which give some substance to his life and clues to his character and influence, and exhibition reviews which place his work in the context of his contemporaries. Fortunately, internet searches have turned up unexpected gems, which have revealed Inston as a photographer with an international reputation.

Added up, these few pages together provide little more than the thinnest biography but, ultimately, it is his surviving photographs that are the focus of this book and this is the first time a monograph of his work has been published. There are problems even here, for many of the images are copied either from lantern slides or small contact prints. Neither format is ideal but they are all there is to work from. Fortunately, the small number of exhibition prints in the possession of the Royal Photographic Society, show Inston's craft at its best.

Charles Frederick Inston was born the son of Joseph, a carpenter, in Birmingham in October, 1855. Presumably he served an apprenticeship as a printer for, by 1879, at the age of 24, he was trading in his own name as a lithographic and general printer from premises at 72 South Castle Street, Liverpool. In 1881, he married Kate (born Woodchester near Stroud in 1858) in Liverpool. His business had moved a short distance to 25 South John Street and his home address was Chapel Road in Anfield. The only other snippet of information I have found relates to his membership of the Kirkdale Lodge. Freemasonry was an important source of contacts for a young businessman, so there was no great significance to his membership.

When Inston began to take photographs is not clear. As a printer, however, he will have been very much aware of the technical aspects of reproducing photographs, which were about to revolutionise printing. (Up to the 1880s photographic images had to be copied as engravings before printing). At the same time, the innovations in hand-held photography created a tremendous surge of public interest, which was reflected in the growth of amateur clubs from about 40 in 1885, to over 250 a decade later. Liverpool was very much on the photographic map, membership of LAPA had

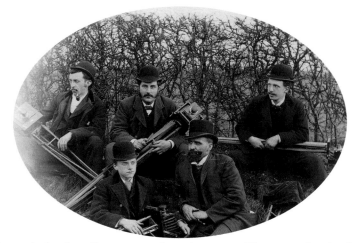

The explosion in interest in photography was reflected in the rapid growth of amateur photographic societies. Here members of Liverpool Camera Club pose for a group photograph during an excursion to Burton in April, 1892. (Photo. J Hawkins).

reached 303, and the leading magazine *Amateur Photographer* had a Special Correspondent who reported on Liverpool and district.

The focus of photographic societies was the exhibiting of members' work and the more ambitious clubs held open exhibitions for wider submissions, with gold, silver and bronze medals conferred by judges for the best images. In 1888, LAPA held its first big exhibition at the Walker Art Gallery. This was remarkable in that it was the first time a photography exhibition had been held in a major art gallery and it represented a considerable act of courage for the Curator of the Walker in the face of considerable criticism from the arts establishment, who regarded hanging photography in an art gallery as setting a dangerous precedent. The international exhibition was on a large sale with 2,000 photographs shown. The catalogue for the exhibition indicates a comprehensive display of both the technical and artistic aspects of photography, with a smattering of well-known photographers, including Frank Meadow Sutcliffe, who had over 30 prints in the exhibition. Over 25,000 attended the one month exhibition – which made a profit for LAPA and encouraged the society to host a second, larger, exhibition held in 1891, with 4,200 photographs. Again, there were numerous categories for technical as well as artistic entries and, again a small number of known photographers exhibited including Alfred Stieglitz, Sutcliffe, George Davidson and Henry Peach Robinson. Once again, the exhibition was hugely successful, with 53,000 attending and a small profit made.

Inston was not directly involved in either exhibition although, as a member of LAPA, it is inconceivable that he did not visit both exhibitions and acquaint himself with the work of Sutcliffe and others.

INFLUENCES ON INSTON

JOHN THOMPSON (1837-1921)

Thompson had photographed in the Far East before returning to London in 1875. In 1877 he worked with a radical journalist, Adolphe Smith, on a study of London's poor. The first social documentary of its time, it was published as *Street Life in London*. A milestone in photography, it popularised the idea amongst photographers of seeing the poor as 'characters'. The impact of more portable and hidden cameras made photography on the streets 'safer' and the results more candid. In the 1890s, many photographic societies had a specific category for street scenes and characters in their competitions and exhibitions. The Manchester photographer Samuel Coulthurst writing in the British Journal of Photography in 1895 commented:

What better mode of recording for future reference, the life and character than the hand camera – our street trades, such as the organ grinder, street artist, hawker, scissor grinder etc., will soon be objects of the past and pictures of them will be of as much value to the future artist and historian as a set of pictures of old houses.

Thompson's work was well known to photographers and his portrayal of misery, 'The Crawlers' of a woman minding a child, was a theme copied by others, including Inston.

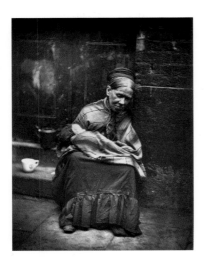 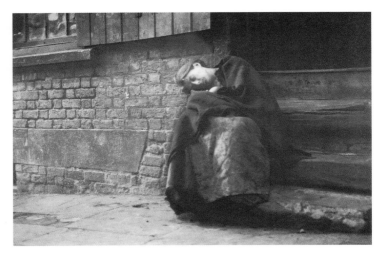

'The Crawler', one of Thompson's most popular images was much copied. Inston's version on the right, has captured the same abject misery.

The Facile hand camera was initially popular but its bulk made it cumbersome. Martin disguised his to look like a parcel to capture truly candid photographs.

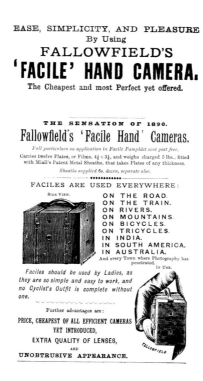

PAUL MARTIN (1864-1944)

Martin's background, like Inston's, was in printing. A wood engraver by training, he took up photography as a hobby. One of the pioneers of the hand-held camera, he used a Facile detective camera, which he held under his arm disguised as a parcel. Although hardly a manoeuvrable camera, weighing in at 5lb, it did allow Martin to take truly candid photographs without influencing his subjects' behaviour.

Martin's work appeared in exhibitions and in *The Amateur Photographer* and, as the demand for wood engraving declined, he took up photography professionally. Approaching his work as a financial enterprise and without any apparent social motivation, he saw a commercial opening for images of street characters and took photographs that he could manipulate (using his experience as an engraver to isolate the main character from his or her surroundings to stand out against a black background) for sale as prints or lantern slides.

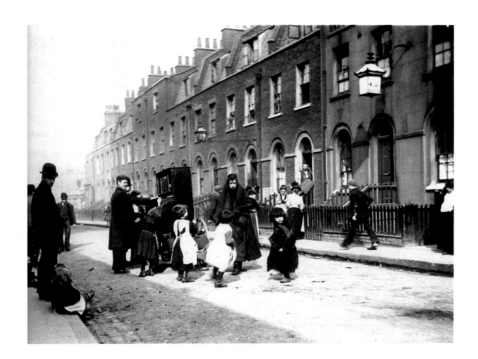

Dancing to the organ, 1893.
(Paul Martin).

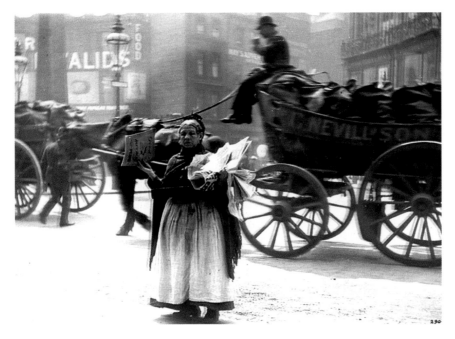

The newspaper seller, 1893.
(Paul Martin).

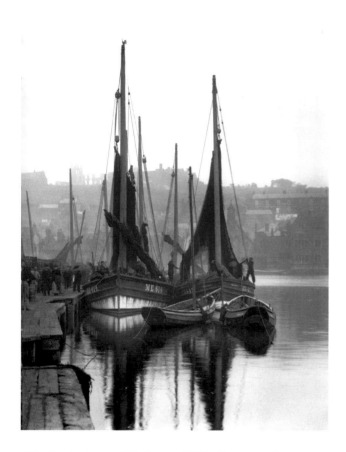

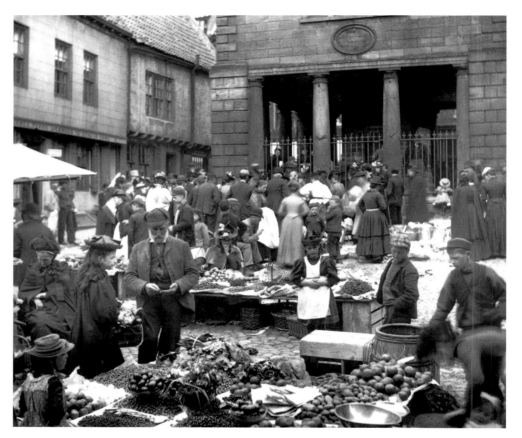

Whitby harbour (F.M. Sutcliffe). Inston, like
Sutcliffe, had ready access to busy port scenes and
the combination of water, sailing ships and harbour
activity was all a photographer could wish for.
Whitby Market Place, 1884 (F.M. Sutcliffe). The
market scene was another much-copied genre.

FRANK MEADOW SUTCLIFFE (1853-1941)

Sutcliffe had started his photographic career in his teens, encouraged by his artist father Thomas Sutcliffe, who owned one of the first cameras in Yorkshire. In 1870, the family moved to Whitby but the premature death of his father in 1871 left Frank as the breadwinner. After an unsuccessful attempt running a studio in Tunbridge Wells, he returned to Whitby. Setting up a studio in Waterloo Yard, he planned to take advantage of the rapidly growing tourist trade. His business prospered and he was very successful as a portrait photographer, particularly during the summer months. He saw this kind of work as necessary but onerous, and at odds with his artistic sensibilities (no doubt passed down by his father). In one article, he comments wistfully: *How I envy that Italian photographer who can refuse to take all sitters but those he thinks will make good pictures.*

Influenced by P.H. Emerson, whose photographs of life on the Norfolk Broads had been widely circulated, and French realist painters such as Corot and Courbet, Sutcliffe focused his lens on the landscape and inhabitants of Whitby and the surrounding area; the fishermen and women, jet workers, farmers and children at work and at play.

Sutcliffe's work had an extraordinary appeal and was widely shown, collecting numerous medals. He was the first photographer to have a one-man show held by the Camera Club in 1888 and was on the Selecting and Hanging Committee of the Royal Photographic Society (RPS). Inston was not just aware of Sutcliffe's work, having exhibited alongside him at numerous exhibitions, but also knew him as a fellow committee member and judge at the RPS. Sutcliffe was also a judge at the Manchester 'Northern' in 1906 at Inston's invitation.

A criticism of Sutcliffe was that he posed his subjects to maximise artistic effect. He would pay a few pence, particularly to the children, to create pleasing compositions. To some extent, he had little choice. He continued using his large, glass-plate camera which necessitated a tripod and lengthy setting up time, well after the introduction of lighter hand-held cameras. As he remarked in 1900 in an article in Amateur Photographer:

I have been taking photographs with an old camera for twenty five years. A year ago I started in with a new camera. I had got pretty well tired of taking photographs with the old

Opposite. Sutcliffe knew his townsfolk well and could readily persuade them to pose for him (often paying small amounts for their co-operation). Here, a fisherman sits on a wooden capstan whilst talking to his friend. Inston chose to have his two boys reading a newspaper on the steps of Liverpool's Custom House. This is one of a series of similar photographs (see pages 66-67). It is a moot point as to whether the boys could read but it is likely Inston paid them a few pennies to make a pleasing composition.

camera. The old camera had, like its owner, got tired. The screws which held it together had got tired of 'biting', they were continually 'leaving go' either the front or the back of the camera; either the weight of the dark slide behind, or the weight of the lens before, was like the last straw on the camel's back, just as the weight of the camera and its six dark slides often felt like the last straw on my back.

I used to fill the slides with plates and go out into the country in search of the picturesque, but before I had got clear of the town, I had forgotten my quest altogether, for the camera began to get so heavy that the picturesque was forgotten and my thoughts were entirely confined to the burden on my back, and the weights I carried in either hand. Yet, as an Englishman, I did not like to feel beaten, so I used to trudge on, the camera getting heavier all the way, till at last a rest was imperative.

If there happened to be a picture near the spot, well and good; if not I either went on or back as the spirit moved me.

Inston, an early proponent of the hand-camera, was less acquainted with his subjects than Sutcliffe, who lived amongst the relatively small Whitby community and knew each person he photographed by name. A familiar sight, he could set up his camera without creating any hostility or great curiosity. Inston did not have such an advantage and for most of his photographs, he relied on the hand-held camera for a candid shot but it is clear that he too posed his subjects. The photographs of the boys (or Street Arabs) reading newspapers on the steps of the Custom House are clearly posed, as are the shots of immigrants showing off their national costumes. Whether Inston paid his subjects is not known but it is clear he had their willing co-operation for such photographs.

INSTON THE PHOTOGRAPHER

Inston's photographic career was developing to the extent that he was elected a member of the Royal Photographic Society in 1896 (and a Fellow in 1901). He immersed himself in the world of the amateur photographic societies and his work was regularly awarded medals. In 1897, for instance, he won the Bronze medal for 'The Lowest Ebb' at Exeter (described as 'the finest photographic exhibition held in the city' *Trewman's Exeter Flying Post*). However, it was the annual Royal Photographic

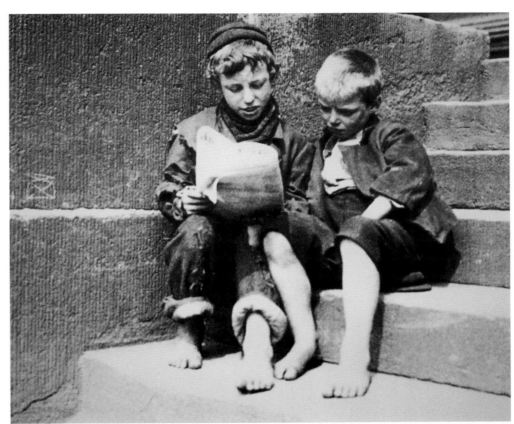

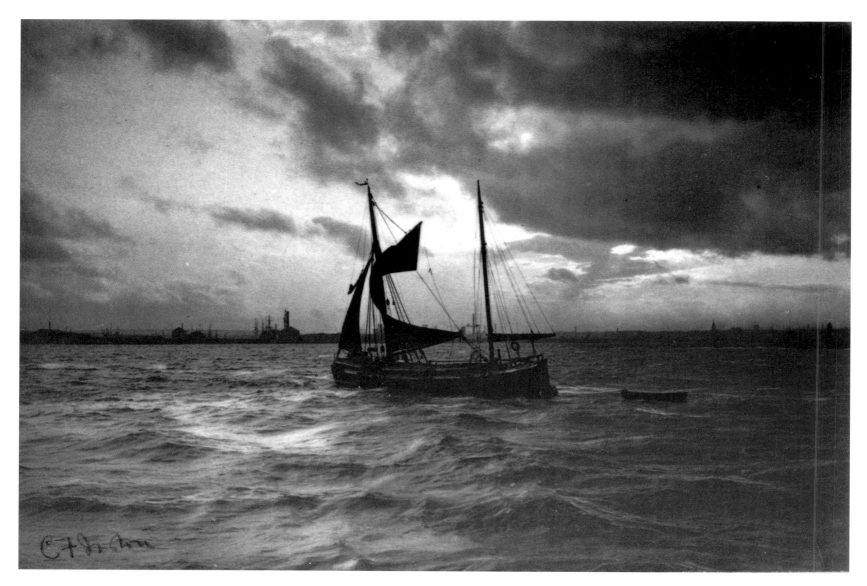

Storm Lifting (1896).

Society exhibition that Inston and his fellow club members most aspired to for not only was it held in London, with all the press attention that entailed, but it was also a truly international exhibition with many of the great names in photography submitting their work. It was the best gauge of where photography was at that point in time and Inston was acutely aware of the prestige of having his work regularly chosen. In the 1898 catalogue, he is singled out for praise:

C.F. Inston has done still better hand-camera work this year than even before. A Pastoral, sheep beneath a spreading tree, is in every sense a picture, and a good one at that; while of his fine seascapes, The Storm Lifting (already medalled at Dublin and Exeter) and The Storm Breaking are as good as they can be. In street scenes we find the same excellent choice of the right moment so that is hard to believe the actors were not posed for their parts. The Latest News, three street Arabs; The Argument, a group of working men on a bench; Industrious Old Age, a good old lady knitting; Contented, an old workman reading a newspaper, and By Suffering Worn and Weary, are each in their way very good but possibly the last named is also the best ...

One of Inston's entries in the 1900 Royal Photographic annual exhibition was received with even greater critical success:

Unqualified praise must be given to 'Whence and Whither?' This fortunate glimpse of majestic sea dappled by silver light is, in our opinion, one of the really good works of the year. Often as the sea has been photographed with a view to emphasising its various aspects, we remember no picture that has given us the moving swirl and irresistible power of the wave that is not breaking, that merely lifts and moves itself forward. Somewhat akin to this, though different in its total intent was the wave under R. Demachy's 'Fishing Boat' of last year and another comparable example is in one of George Davidson's little panoramas in this year's Salon. Neither of these attempts the reserve, the grandeur and the power of Inston's single wave.

Inston was not just a copyist. An editorial by W.R. Bland in *Photograms of the Year 1916* made it clear that he considered Inston had contributed important original work

... within comparatively few years we have seen the conception of the pictorial character of sea pictures enhanced almost out of recognition by the work of P.J. Mortimer, who, in addition to quite new ideas of rendering physical features, has embodied the priceless virtues of feeling and mood. True, before this we had had striking pictures of stormy seas and wave-dashed rocky

coasts, but they were mainly spectacular. There is always to be remembered the notable exception of C.F. Inston's "Whence and Whither?" reproduced in "Photograms of the Year 1900," p.173, which was, probably, the pioneer of the intimate personal feeling in sea pictures.

A later critique by Margaret Harker (Chair of the Collection Committee RPS) makes an interesting point about Inston's artistic leanings, away from the prevalent impressionism which was being practised by many of the leading photographers.

Inston's work reflects the influence of Dr P.S. Emerson in the clarity and quality of the image displayed here in 'Low Tide'. This adherence to the principles of naturalistic photography is interesting at a time when impressionism was so much in evidence in the work of fellow photographers.

Harker touches upon one of the most interesting periods of photographic history. By the late 1880s, to have one's photographs hung at the Royal Photographic Society's annual show was one of the highest accolades. However, members were split over the perceived emphasis on technical and scientific photographs rather than aesthetic. A leading photographer, Henry Peach Robinson expressed his exasperation in an article in *The Photographic News* (1892):

If photography is ever to take up its proper position as an art it must detach itself from science and live a separate existence.

Separation was not acceptable to the broad membership of the RPS, whose interests in photography encompassed astronomy, microphotography and other technical areas. The pressure was building up and a split became inevitable with Robinson and another leading member, George Davidson resigning their membership in 1892 along with a number of other distinguished photographers.

Following his resignation, Robinson founded the Linked Ring Brotherhood, a group of photographers pledged to enhance photography as a fine art. The Brotherhood used as its logo three interlinked rings, which represented the masonic beliefs of Good, True and Beautiful. Membership was by invitation only and soon included many of the most important photographers such as Sutcliffe, Paul Martin, Frederick Evans and Alfred Stieglitz.

The Linked Ring began to actively pursue its aim of *bringing together those who are interested in the development of the highest form of Art of which Photography is capable*

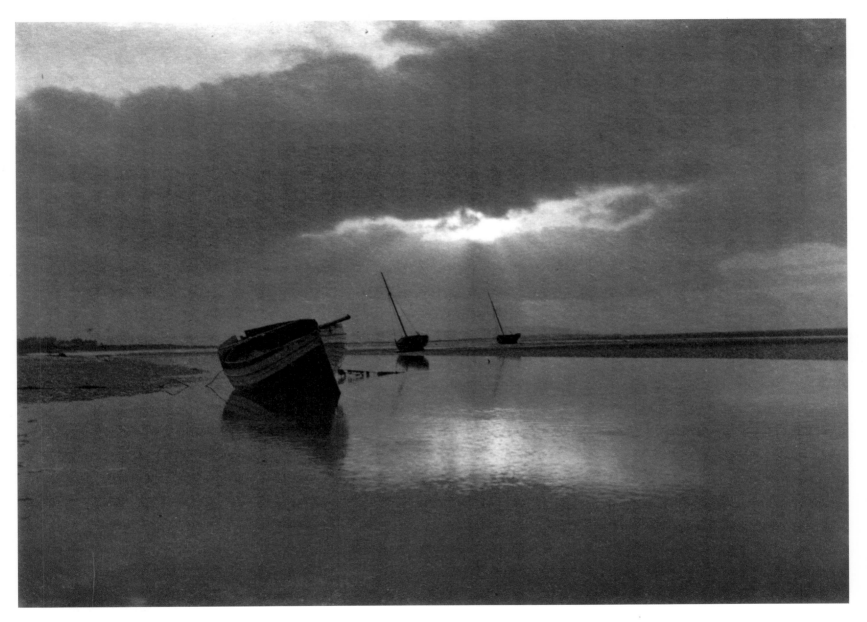

Low Tide (1900).

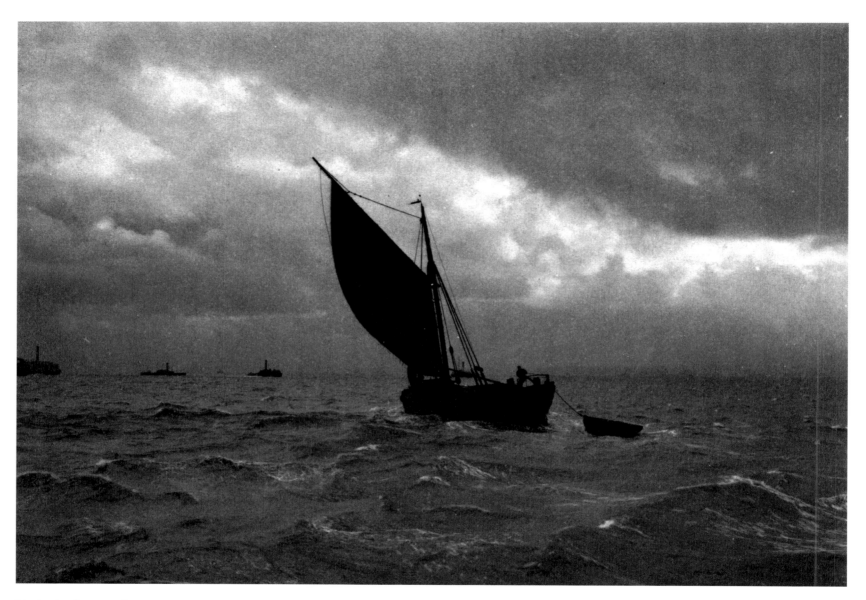

End of a Stormy Day (1901).

through exhibitions and publications. Its first important show, the Photographic Salon (the name deliberately chosen because of its association with exhibitions of paintings) was a success and became an important annual event. In 1896 it began publishing *The Linked Ring Papers*, which were circulated annually to members until 1909 to promote and discuss the aesthetics and practice of pictorialism. Its other publication, *Photograms of the Year* became the standard bearer for the best in art photography.

The members of the Linked Ring were searching for new ways of artistic expression and discovered it in the heavy manipulation of both the negative and the print to produce moody, atmospheric works.

The French photographer Robert Demachy put forward his approach: *It makes no difference to me if the amateur uses oil and eraser or platinum, if he daubs his plate or attacks it with a knife, so long as he offers me a picture which his neighbour cannot easily duplicate!*

A cynic might detect an unhealthy strand of elitism and pretentiousness in the Brotherhood's stance, which was particularly aimed at the rapidly growing number of amateur photographers experimenting with photography for the first time. Anyone could now take a picture and the established photographers no doubt felt threatened by this sudden democratisation of their medium.

The interesting question from this book's perspective is whether Inston was ever invited to join. He was known to all the members, his work was widely respected (and included in their Photographic Salon and *Photograms of the Year*) and he was a freemason, with an appreciation of the symbolism of the linked rings and the 'brotherhood'.

Membership was by invitation only and any one member could veto a candidate. Possibly Inston was blackballed but I can only surmise that he was invited but refused because of his commitment to the Royal Photographic Society. He was, by that time, a member and had thrown himself into the affairs of the Society. Perhaps he felt membership of the Linked Ring would be seen as a betrayal. After the initial split, the relationship between the Linked Ring and RPS became more harmonious and members of the Brotherhood, including Dudley Johnson, a fellow member of Liverpool Amateur Photographic Association and later president of the RPS, kept their feet in both camps.

What is clear is that Inston kept an open mind about photography and maintained close links with leading photographers. In 1906, LAPA held an exhibition of the work of an outstanding young American photographer, Alvin Langdon Coburn, then aged 23 and a member of the Linked Ring. A catalogue was published for the exhibition with a preface by George Bernard Shaw (the preface in fact was twice as long as the catalogue itself). Coburn's work was described as 'brilliantly original work which has never since been equalled for sheer originality'. (Dudley Johnson recorded that he took a party of Liverpool photographers including Inston and A. Langdon Coburn to Birmingham to meet a party of his friends).

Perhaps the most significant mark of Inston's status was the inclusion of one of his images in Volume 6 Number 1 (1902) of the key American publication *Camera Notes*. *Camera Notes* was published by the Camera Club of New York from 1897 to 1903 and edited for most of that time by Alfred Stieglitz. Considered the most significant record of photographic aesthetics of the time, it is particularly valued for its many high-quality photogravures by photographers such as Stieglitz, Clarence White, Gertrude Kasebier, Robert Demachy and F. Holland Day. Each issue was an art object in itself, and for Inston to have been selected by Stieglitz for such a key American publication was acceptance at the highest critical level. Inston was clearly seen as a man of international stature and not just a provincial photographer with parochial interests.

Possibly the photogravure in *Camera Notes* marked the pinnacle of Inston's career as a photographer because, from approximately that time, he became increasingly involved in the affairs of both LAPA and the RPS, particularly in organising the 'Northern' photographic exhibitions of 1904, 1907 and 1911.

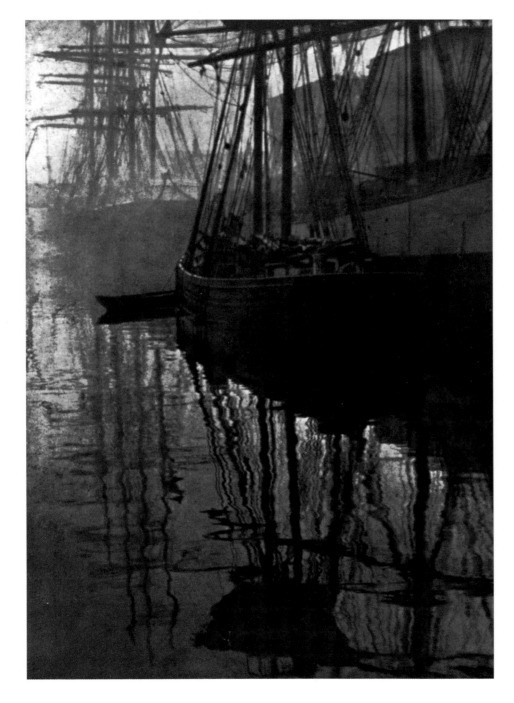

The Spider's Web, Liverpool, 1906. (Alvin Langdon Coburn). Coburn was a brilliant American who stunned the photographic world with his original approach. Given a one-man show for the Royal Photographic Society at the age of twenty four (the same exhibition was held later that year in Liverpool by LAPA), Coburn's impressionistic style was highly influential, involving the extensive manipulation of the image at the printing stage. Inston's Liverpool Dock 1910 (page 44) has echoes of Coburn's style.

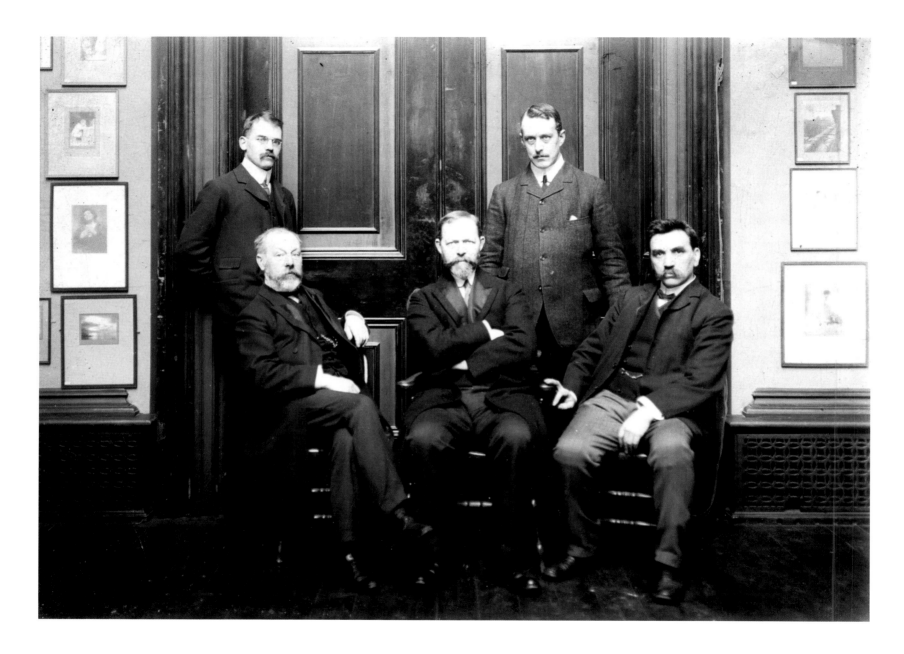

THE 'DUKE OF SECRETARIES'

At the end of the nineteenth century, LAPA, along with Manchester Amateur Photographic Society and Leeds Camera Club, decided to run an open exhibition to be held successively in the three cities, starting at the City Art Gallery in Manchester in 1898 and Liverpool following in 1901. The format appears to have changed with the next exhibition, the first under the name of Northern, held at the Walker Art Gallery in 1904, with Inston as Secretary.

The exhibition was a great success, with exhibitors including Frederick Evans, J. Craig Annan, F.M. Sutcliffe and F.J. Mortimer. The judges were Harold Baker, Horsley Hinton and Alexander Keighley. Inston's hand was on every aspect of the show; the catalogue was printed on his company's press (he also printed catalogues for the 1907 and 1911 exhibitions) and his photographs drew praise:

Looking round the exhibition, we note many good things deserving of notice, C.F. Inston's fine sea and shipping studies attract at once and leave a lasting impression of good sound work.

The Northern established itself as the most important exhibition outside of London. In 1936 Dudley Johnson wrote about:

the efforts that are being made to persuade the authorities of Art Galleries that Photography is, or can be, Art with the big A. Many of us have been making these efforts for many years with varying success. Thirty years ago, when I was first identified with the Liverpool Amateur Photographic Association, that most energetic of secretaries and fine photographer, Charles F Inston, succeeded in persuading the City Council to give us the use of the (Walker) Art Gallery for the Northern Exhibition, which was almost the greatest exhibition of pre-war days, and with the backing of the very broad-minded Curator, E. Rimbault Dibdin, this privilege was continued for many years until war broke the continuity of the Northern.

In 1911, the judges were Frederick Evans and Furley Lewis. Evans was fulsome in his praise:

I have just returned from an enjoyable two days selecting and judging with Mr Furley Lewis at Liverpool; and have had the first hand opportunity of appreciating the capacity for genial hard work possessed by that pattern hon. Sec. Inston. (Why bother about his initials, is he not INSTON, the Duke of Secretaries).

Northern Photography Exhibition, Liverpool, 1908. Back row: C.F. Stuart, J. Dudley Johnson. Seated: J.W. Ellis, Thurstan Holland (Chairman), C.F. Inston (Secretary).
Dudley Johnson became President of the Royal Photographic Society and was responsible for establishing their magnificent Permanent Collection.
Dr. Thurstan Holland, a pioneer of radiology, lived and worked at 43 Rodney Street, Liverpool.

At the same time as organising the Northern, Inston was deeply involved in the affairs of the RPS, serving on the selection committee for RPS exhibitions from 1908 to 1912 and from the latter year until his death as a member of the council of the RPS.

He was also President of LAPA in 1912 and 1913. It appears that his own photographic work was becoming less prolific. The street and dock scenes were completed by 1910 (there is one photograph of the newly completed Mersey Docks and Harbour Board building amongst the photographs) and his exhibition work appears to have tailed off. Clearly illness, business pressures and the work for both LAPA and the RPS were taking their toll.

How active Inston was during the last few years of his life is difficult to ascertain. He had served his presidency of LAPA in 1913 but was still a council member of the RPS. In May 1917, at the age of 61 he died in Liverpool, survived by his wife Kate.

Described as a retired lithographic printer, his effects amounted to £2,023, a modest amount for a lifetime in business. His last house, at 15 Belmont Drive, still stands. Facing outwards from Newsham Park towards Rocky Lane and now in multi-occupancy, its yellow-bricked façade is rather shabby and uncared for. Kate died in her nineties in Liverpool at Greystone Nursing Home, Greenbank Road in 1951. They had no children.

AN ASSESSMENT

Inston's death, even at the height of war, was covered extensively by the photographic press. *The British Journal of Photography* (11/5/1917) set the tone:

It is with very great regret that we record the death on Friday last, May 4, of Mr C.F. Inston, a leading figure in the photographic life of not only the North of England, but of the whole country. First as Secretary (in 1905) and afterwards as President (in 1912 and 1913) of the Liverpool Amateur Photographic Association, during which period the inception of the Northern photographic exhibition came into being. Mr Inston may be said to have stood for photography among the societies of the North. He was, in fact, much more than that. Elected a member of the Royal Photographic Society in 1896 and a Fellow in 1901, he served on the selection committee for the RPS exhibitions from 1908 to 1912 and from the latter year until the time of his death was a member of the council of the RPS. The Northern

Exhibition, first held in Liverpool in 1904, owed its success very largely to his initiatives and great powers of organisation. The original plan was that it should be held in turn in Liverpool, Manchester and Leeds. Without disparagement to the latter two, it may be said that in them it did not attain the great importance which it secured in Liverpool.

Inston's death will be felt chiefly as the loss of a living personality. Although he was an accomplished master of his craft, he wrote little upon it. The single article in a recent publication of the Kodak Company is almost the only thing which appeared from his pen in the last ten years. Perhaps this arose from the fact that, like many similar strong natures, he had not the least desire for self-advertisement. Even when affairs with which he was publicly connected seemed to call for some comment from him, it almost always happened that the occasion failed to draw him into controversy. In him we have lost one of the finest men who have rendered service to photography. In his organising work as secretary and president, he was thorough and indefatigable, governed in all that he did by a shrewd optimism and, above all, honest, to the degree of bluntness, in purpose, thought and action.

Inston, the man of character and organisation, existed side by side with Inston, the technician in pictorial photography, and the personal characteristics of the man were marked equally in both fields of his activities. He was no poseur. He loved artistic work for its own sake. Though not a wealthy man – his business was that of a lithographic printer – his home contained paintings upon which he had spent sums which were large in proportion to his means. His own pictorial work was characterised by a frankness and vigour which were part of himself, features which they did not lose when oil and bromoil were added to the purely photographic media which he employed.

The *Amateur Photographer* magazine echoed these sentiments:

… he was a keen pictorial photographer and lecturer, a leading exhibitor and judge and a clever worker in the bromide, platinum and bromoil processes and also one of the earliest and best demonstrators of the pictorial possibilities of the hand held camera. He was undoubtedly the strong man of the northern photographic societies and there were few things Liverpool amateurs would not do at his request. At the same time he never spared himself in working for and with others and there was the added charm that co-workers with whom he was in contact knew that everything he did was 'straight'. Those who had his friendship knew that beneath his rugged exterior and brusque manner was a heart of gold, a sensitive

nature… that would have surprised others less well acquainted with him … His exhibition pictures have included seascapes, landscapes, figure studies and portraits while his beloved Liverpool Docks and the Mersey provided subjects galore for his camera.

Finally, J. Dudley Johnson, a fellow president of LAPA and later the RPS added a very personal tribute:

In Charles F. Inston, FRPS, who passed away on May 5, Liverpool and the North of England have lost one of the strongest personalities that have exercised an influence on the development of photography. Not that in any sense he was a local influence only, but that his work was largely connected with the Liverpool Amateur Photographic Association, which owes so much to his untiring and devoted labours both as Hon. Secretary from 1905 to 1911 and as president in 1912 and 1913; with the Northern Photographic Exhibition, of which he was undoubtedly the organising genius, and with the Lancashire and Cheshire Union, in which he took a deep interest. He was essentially a strong man, yet one with whom self-interest was the very last consideration. As the secretary of a large society he was ideal. Organisation was his especial gift, and he had that invaluable power of communicating his enthusiasm to others that is one of the essentials of success. Behind a somewhat brusque manner there was concealed a fund of kindness. No beginner ever appealed to him in vain for advice or instruction. No trouble was too great for him to take in imparting any of his wide photographic experience to those who really wished to learn. Only of humbugs and self-seekers was he absolutely intolerant. The transparent honesty of the man endeared him to a large circle of friends and gained him the respect and trust of men of all shades of opinion in the photographic world. For five years as vice-president and president of the Liverpool Society I had the pleasure of working side by side with him and learnt to admire his amazing capacity for work and the energy and foresight of his administration. His latter years must have been clouded by the dread illness that crept upon him, but I am sure his strong will kept him cheerful to the end.

His work was an outstanding feature of most of the exhibitions of the past twenty years. There was a sense of natural beauty in his open-air landscapes and genre pictures that proclaimed his artistic nature and appealed to a very wide circle of admirers. There was nothing sophisticated about them, and it may be doubted whether he was in sympathy with some modern developments of the art, although he knew how to encourage individual expression in others who came under his influence. Of all technical means he was a

consummate master, and the perfection of his platinotype and bromide work was a household word amongst the photographers of the past decade. His 'Storm Breaking' in the permanent collection of the Royal Photographic Society was an epoch-making work in its day.

Dudley Johnson expanded on this contribution in a more expansive obituary in *The Photographic Journal* (May 1917). Repeating his tribute to 'one of the strongest personalities that has exercised an influence in the world of photography during the past twenty years, Johnson adds a number of telling points:

... greatly esteemed as he was by a large circle of photographic workers in London, it was in Liverpool and the north of England where his real life-work was done and where he will be so greatly missed.

Whether his business as a lithographer and printer had any direct bearing on his attraction to photography in the late eighties and early nineties of the last century may be questioned but certainly at a later stage of his career, when the oil process claimed his attention, the connection became obvious and proved of the greatest service not only to himself but to his fellow members to whom his knowledge of inks and other media of the process was of the greatest value. From the outset he devoted himself to the use of the hand camera as his means of artistic expression and the Mersey and the adjacent docks were the hunting ground where he found many of his happiest inspirations. In later days he was attracted more, I think, to pure landscape and many a merry party of photographers has learnt to find the beauty spots of the Derbyshire Dales under his inspiring leadership. He was a true amateur of art, with a deep love of all that was beautiful ... One feels that those exquisite seascapes and landscapes that are familiar to all who have visited leading exhibitions of the past twenty years could have come only from one with a natural sense of beauty highly developed. His earlier work, of which 'Storm Breaking' in the Society's collection, is an admirable example, may be said to mark a definite stage in the artistic progress of photography.

I suppose he carried off every award that was worth having in those years including the Society's medal, at a time when the winning of medals represented a more considerable achievement than it does today. His later work continued to exhibit that quiet sense of beauty that appealed to him, but was perhaps a trifle out of fashion amongst more modern ideals. Of all technical means he was a consummate master and his platinotype and bromide work was a perfect combination of strength and delicacy.

Important as his work was, Inston the man was, however, a far more potent factor in the photographic world. His real work may be said to have begun when he so successfully carried through the first Northern Exhibition at Liverpool in 1904, which had an enormous effect on the status of photography in the north … He had a wonderful gift of organization and also of communicating to others his enthusiasm which is one of the factors of success. He was essentially a strong man, but self-interest was the very last consideration with him. Behind a somewhat brusque manner there was concealed a fund of kindness and all his knowledge and experience were ever at the service of those who really wished to learn …

It would be easy to devalue Inston's contribution to photography. His name rarely, if ever, appears in photographic histories yet he has as much right of inclusion as many of the 'name' photographers of the 1890s and early 1900s. A pioneer of the hand-held camera, his photographs of Liverpool street scenes might be seen as genre pieces in the style of Sutcliffe, Thompson and others. His admiration particularly of Sutcliffe is evident but, although his street work may not be original, it was widely recognised as being amongst the best at that time. His seascapes, on the other hand, were appreciated as truly original and important. Recognition by photographers of the first rank, including Stieglitz and Coburn, cannot be dismissed as inconsequential.

Dudley Johnson pinpoints Inston's real influence. The amateur photographic movement was a potent force for the advancement of photography in the 1890s and 1900s. Societies flourished as large numbers of people realised the medium was within their budget. In 1885 there were only 40 amateur societies in Britain but, within a decade, there were over 250. Inston relished the work of organising and developing the work of the amateur world, not just in his work for LAPA but in a much wider context, particularly in establishing the Northern exhibition as a showcase for photography in the north. However, to dismiss Inston as a provincial organiser would be deeply unkind. A fairer assessment comes from the pages of *Photograms of the Year*:

… while all the shows were valuable, particular interest attached to that of C.F. Inston, the first of the modern generation of Liverpudlians to make a name of world-wide note.

The greatest shame is that with so little of his original work surviving, Inston will remain in the footnotes of history. I hope this book will, at least, make his name and achievements more familiar.

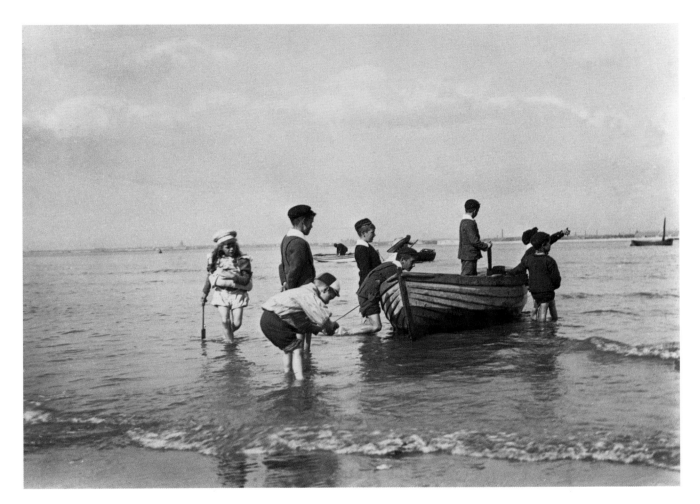

Children and boat at New Brighton, an attractive subject matter
that would score well in photographic competitions.

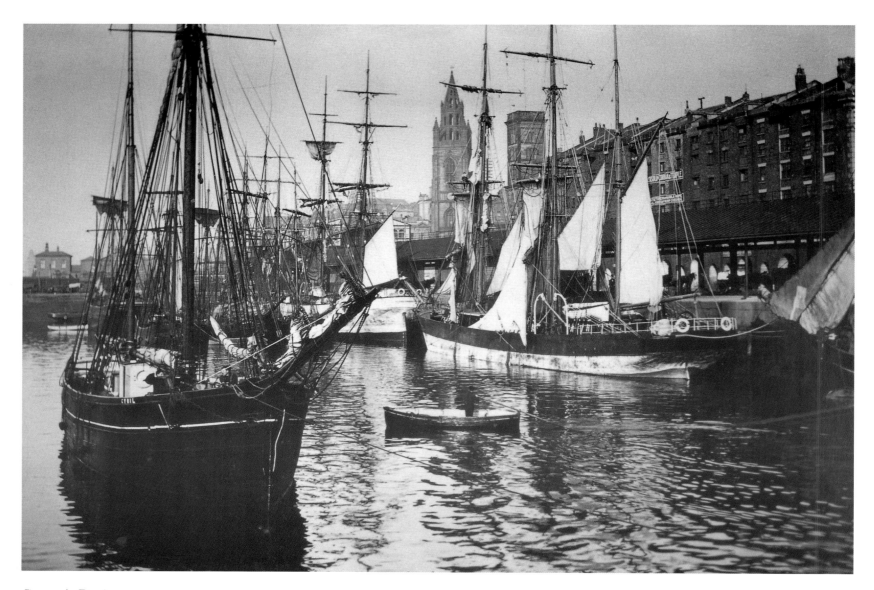

George's Dock.

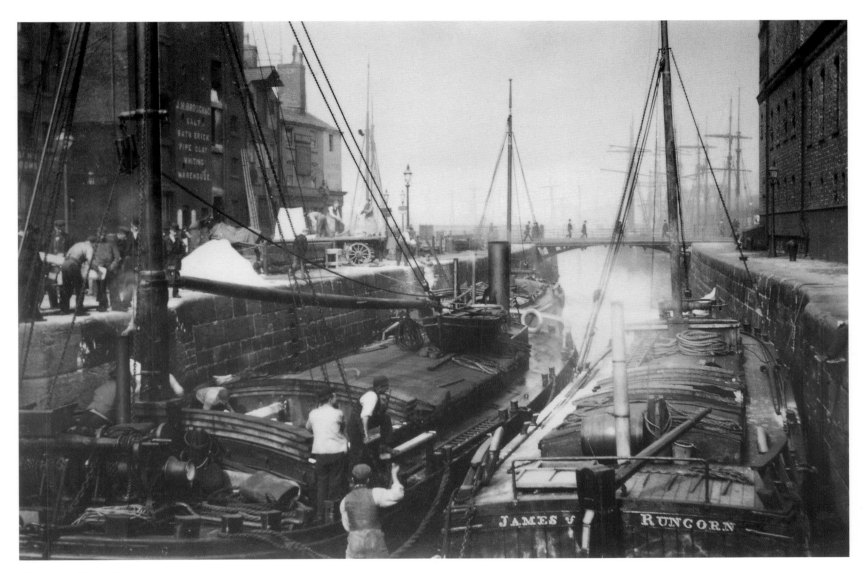

George's Dock Passage.

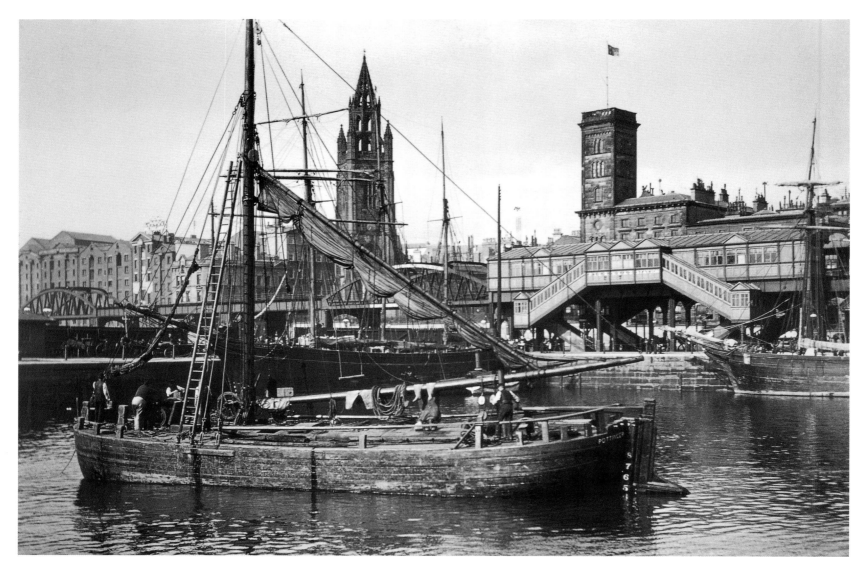

George's Dock, with the newly built Liverpool Overhead Railway.

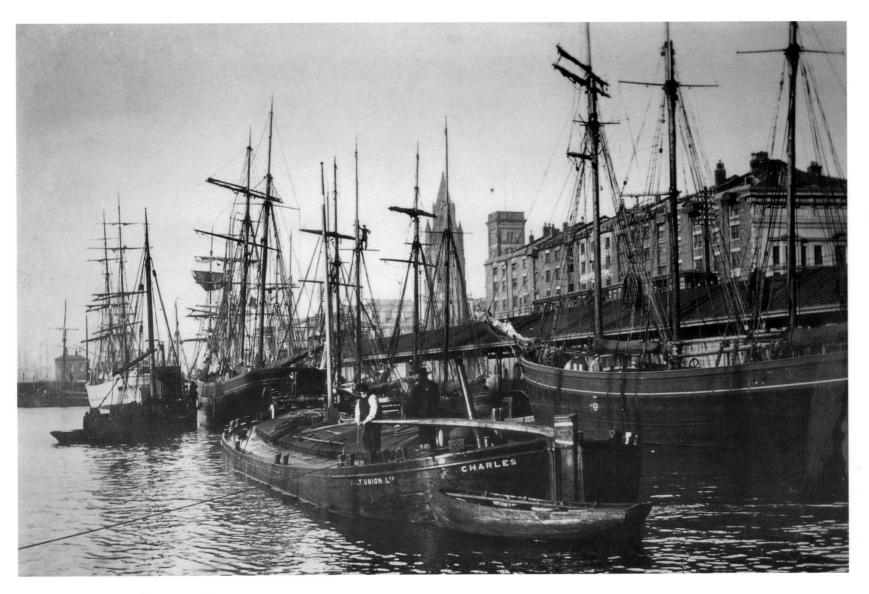

George's Dock and Goree warehouses.

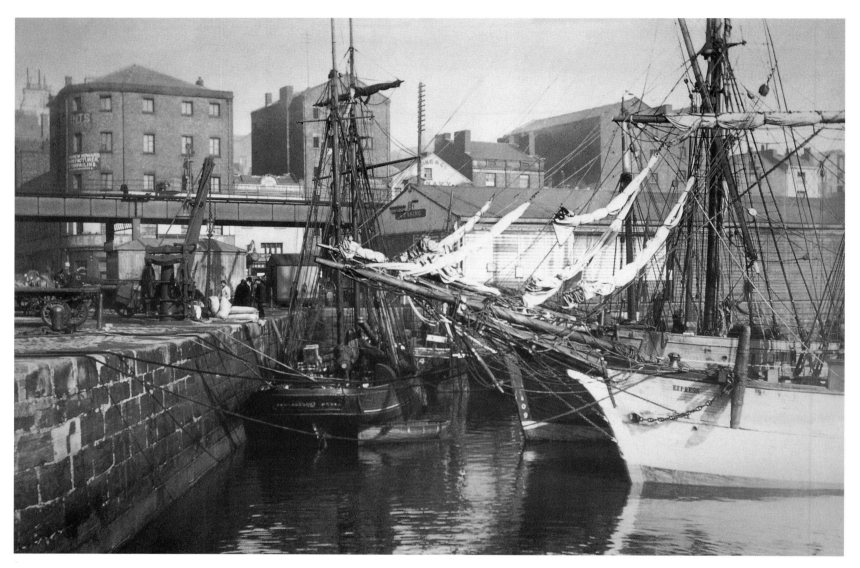

Canning Dock.

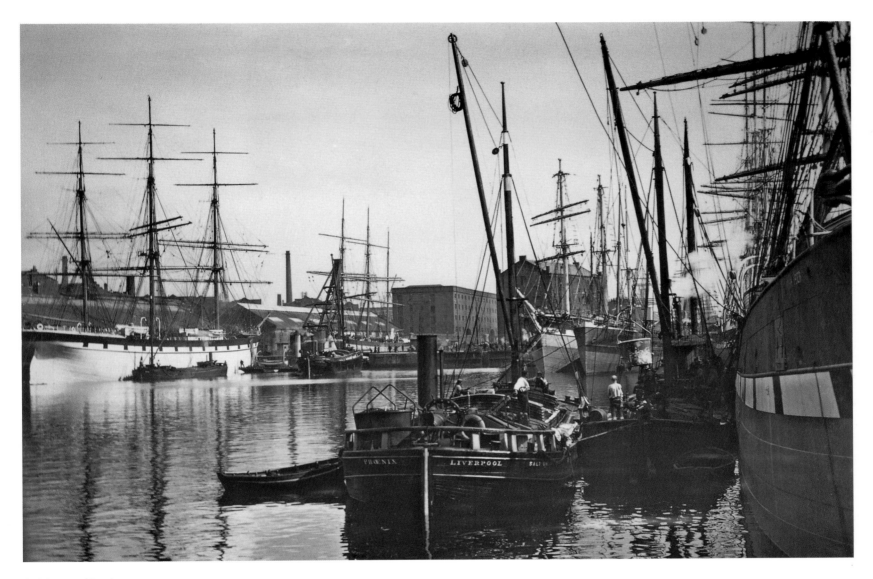

Salthouse Dock.

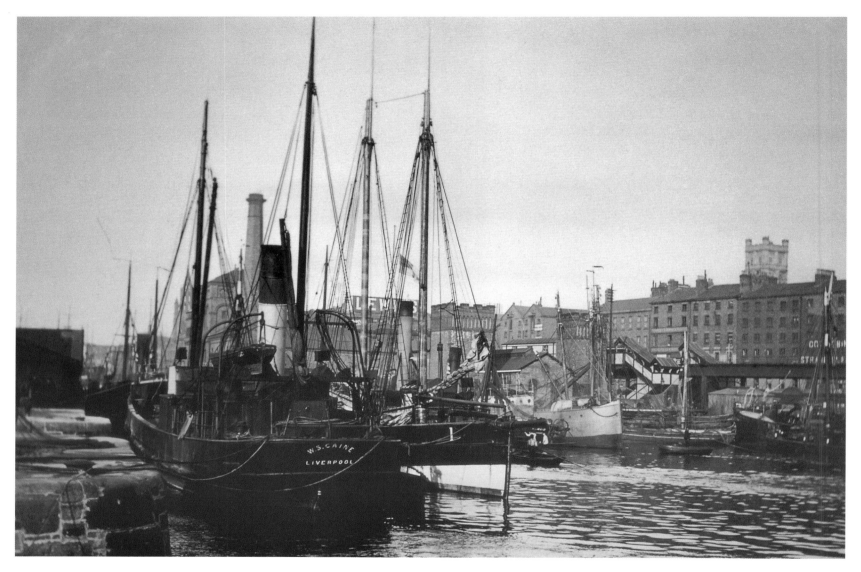

Canning Dock.

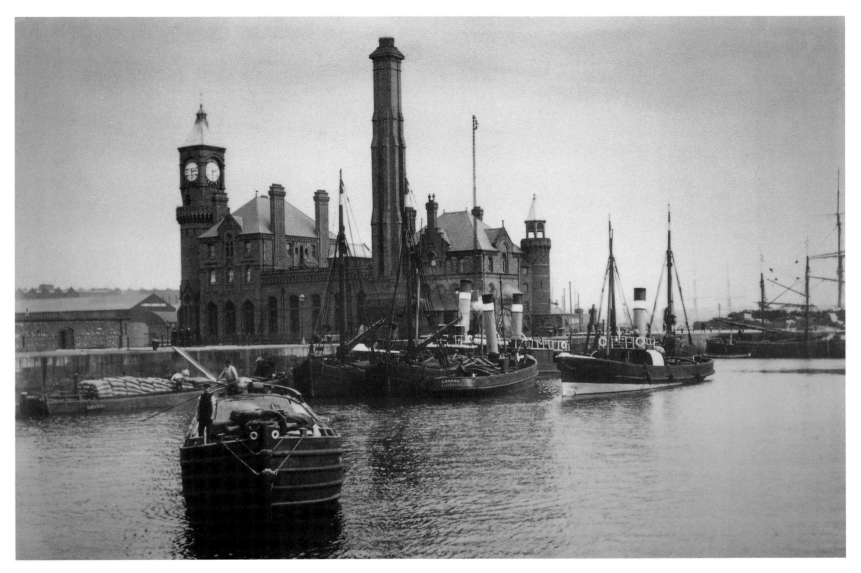

Langton Dock.

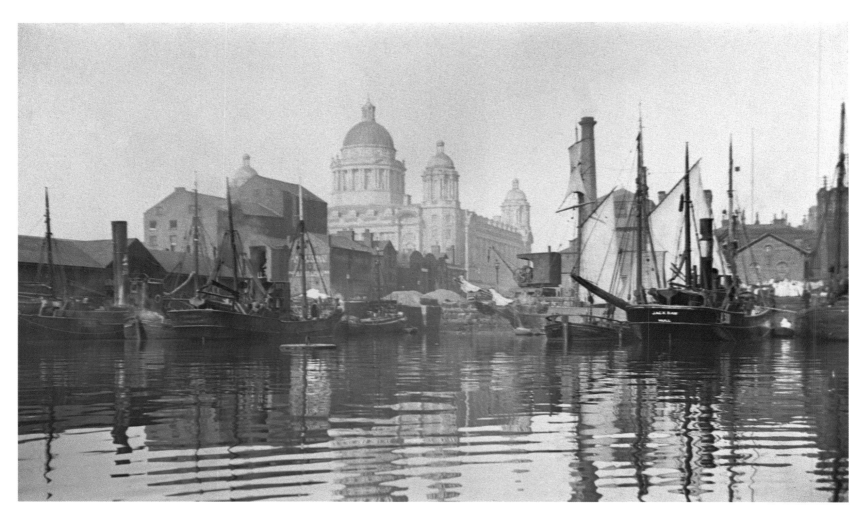

Canning Dock, 1910.

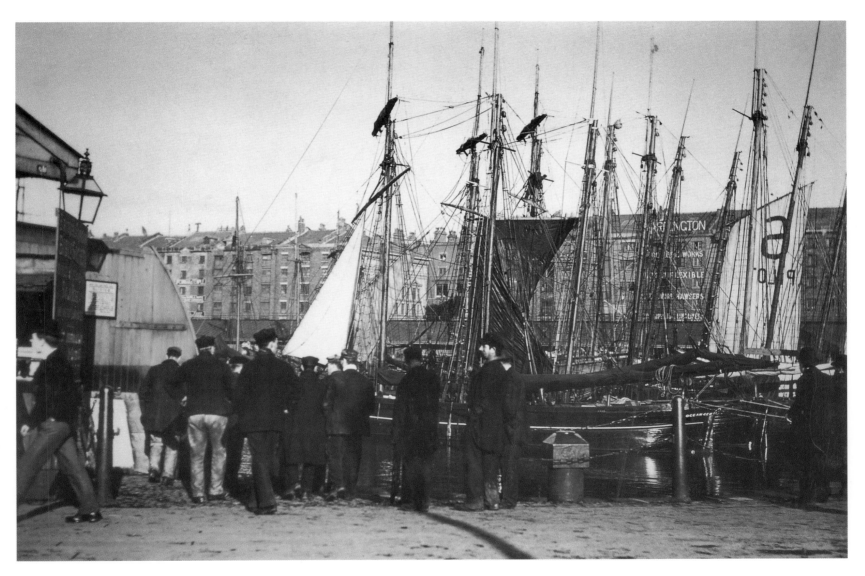

On the quay at George's Dock.

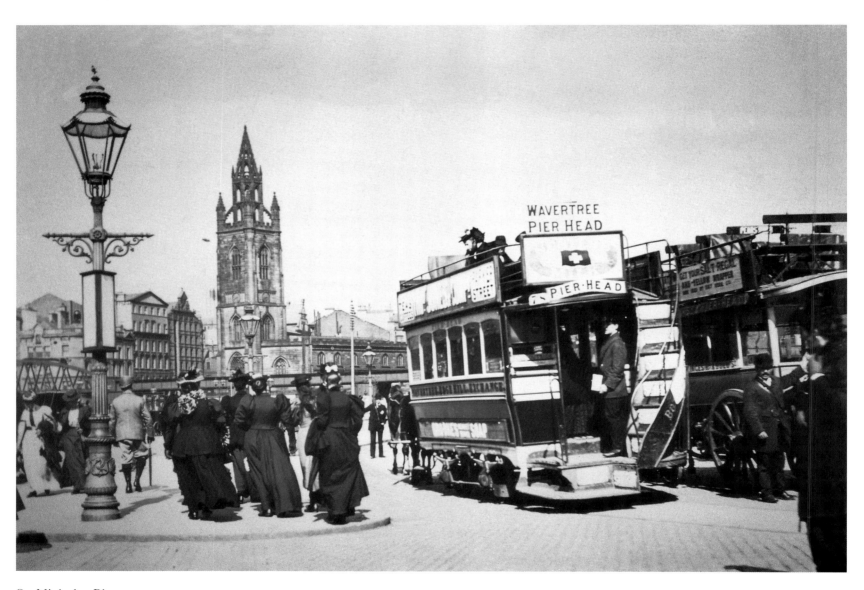

St. Nicholas Place.

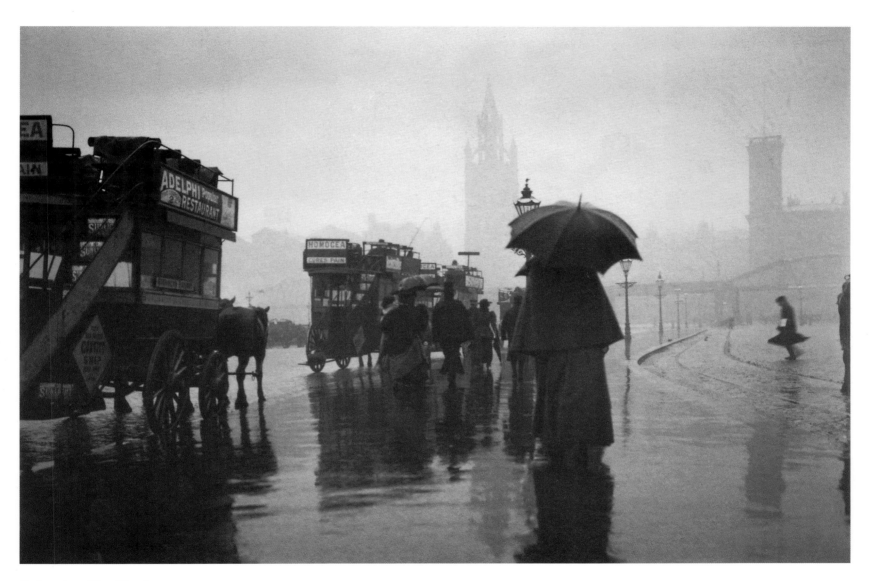

Rainy day, Pier Head.

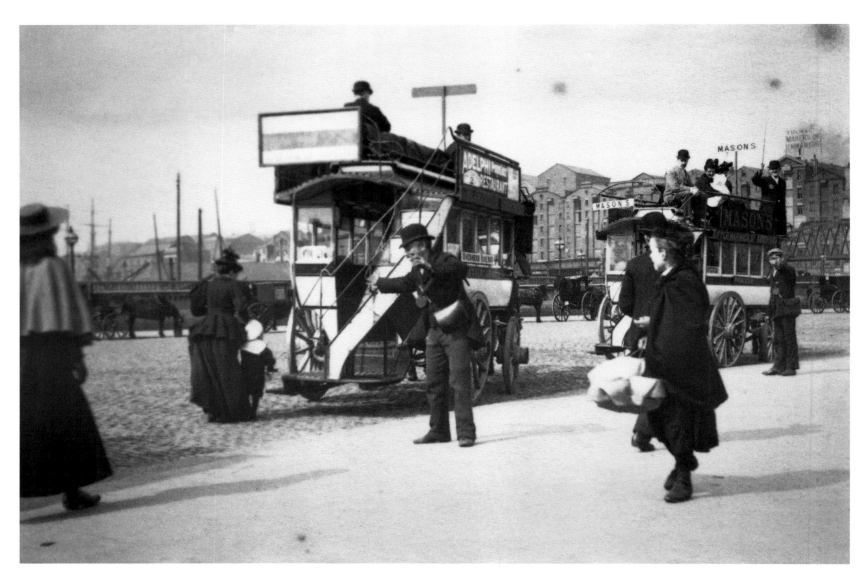

Drumming up custom, Pier Head.

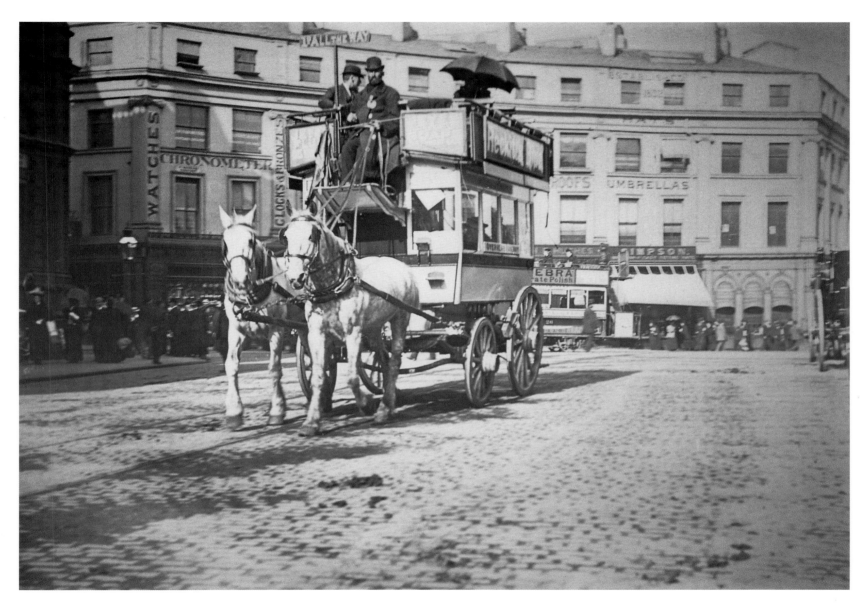

Omnibus, St George's Crescent.

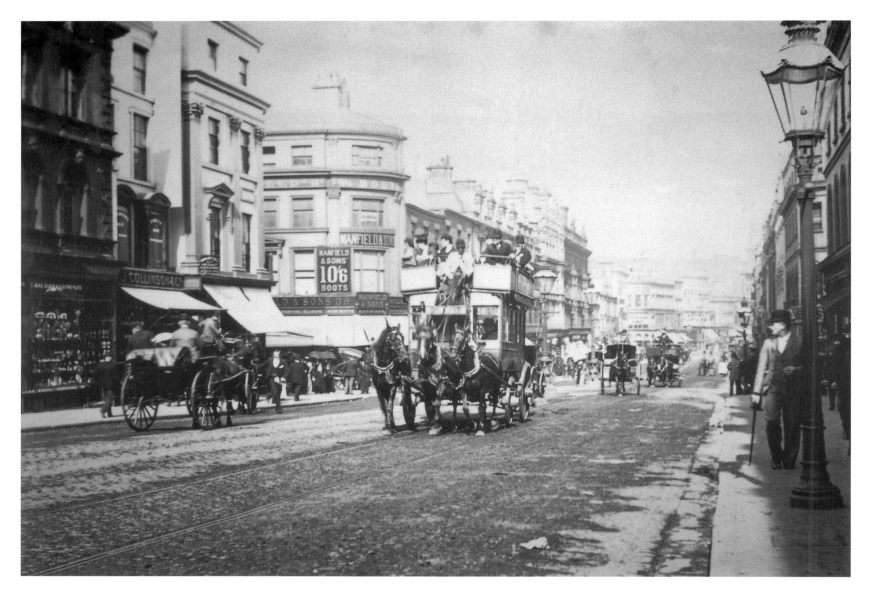

Lord Street.

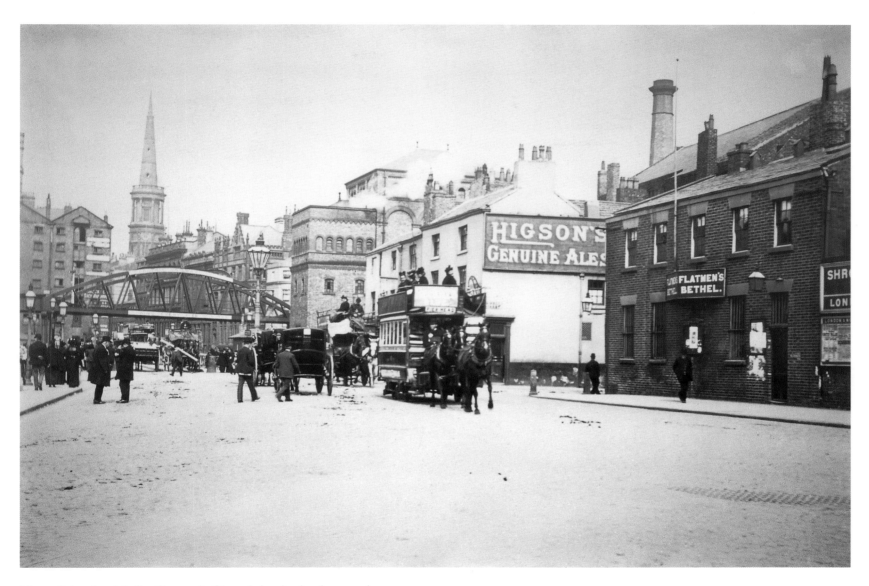

Mann Island, with St. George's Church in the background.

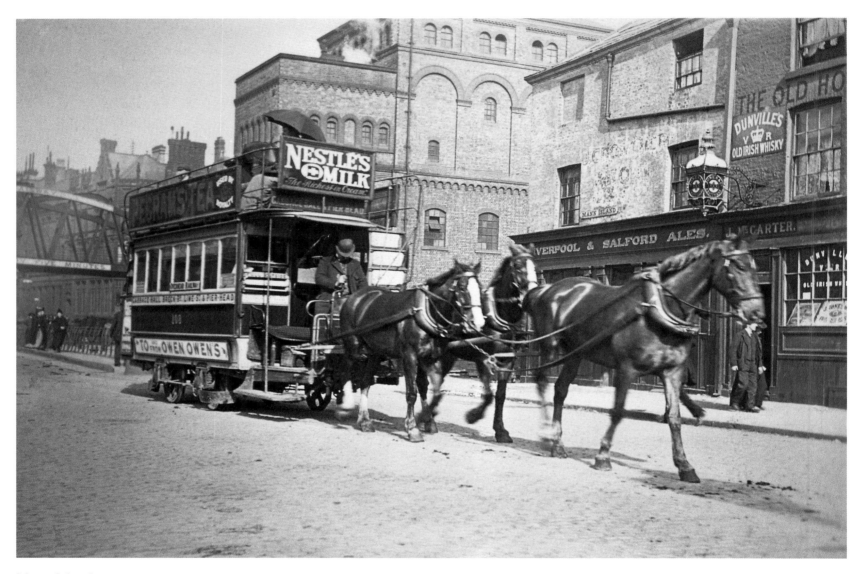

Mann Island.

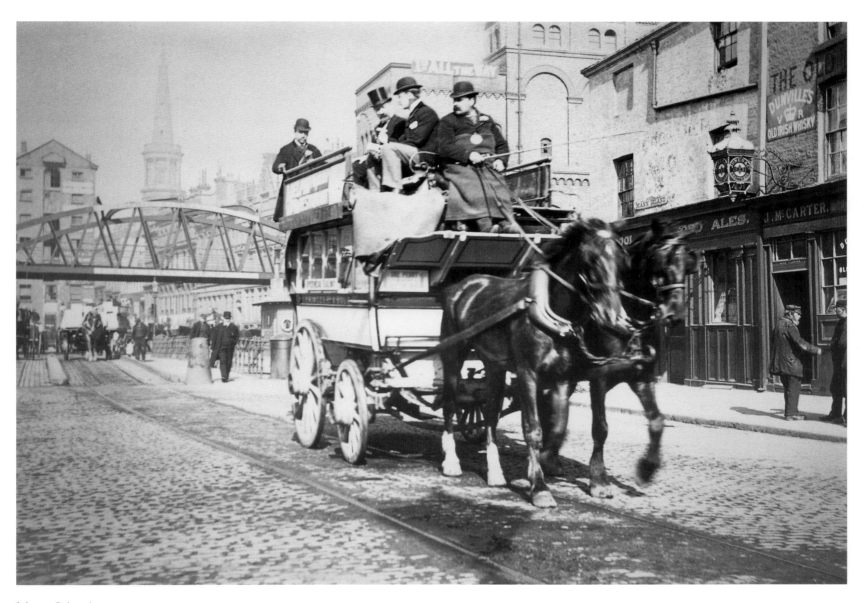

Mann Island.

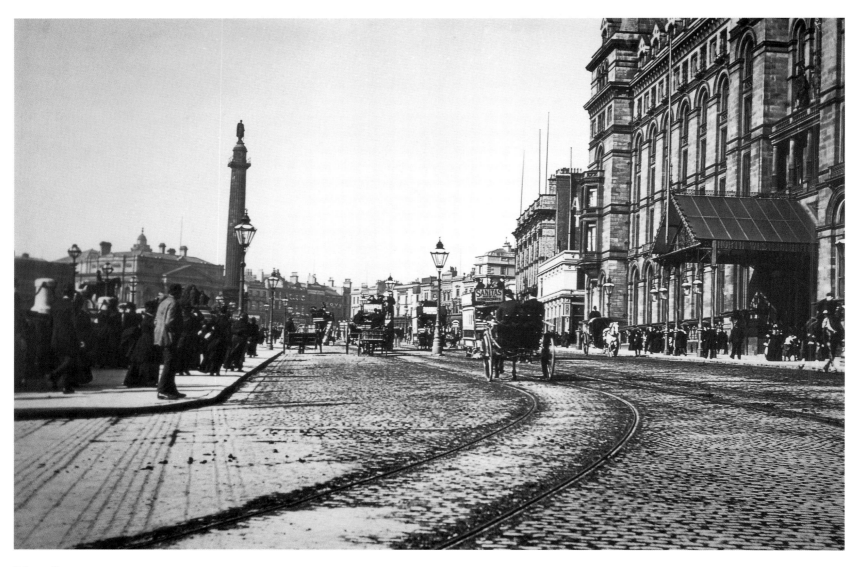

Lime Street.

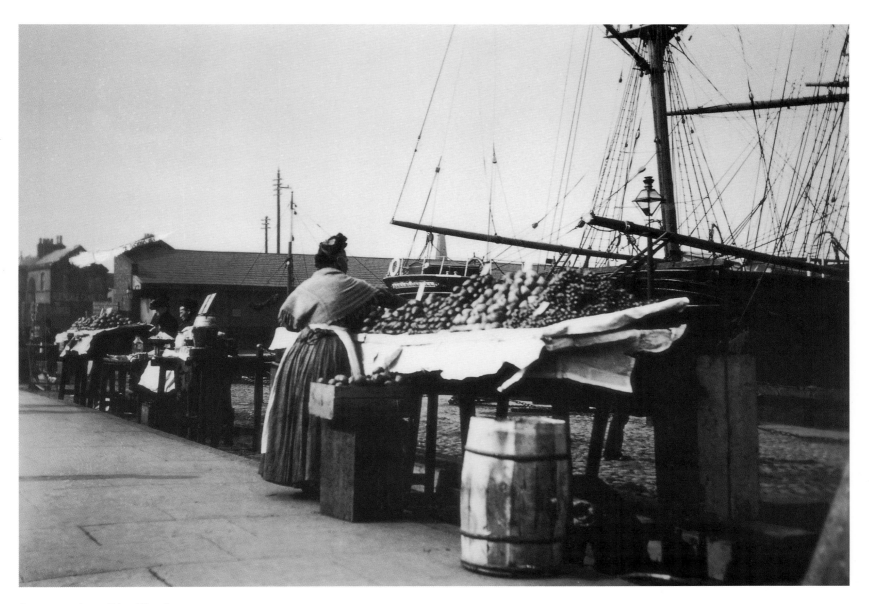

Street traders, Pier Head.

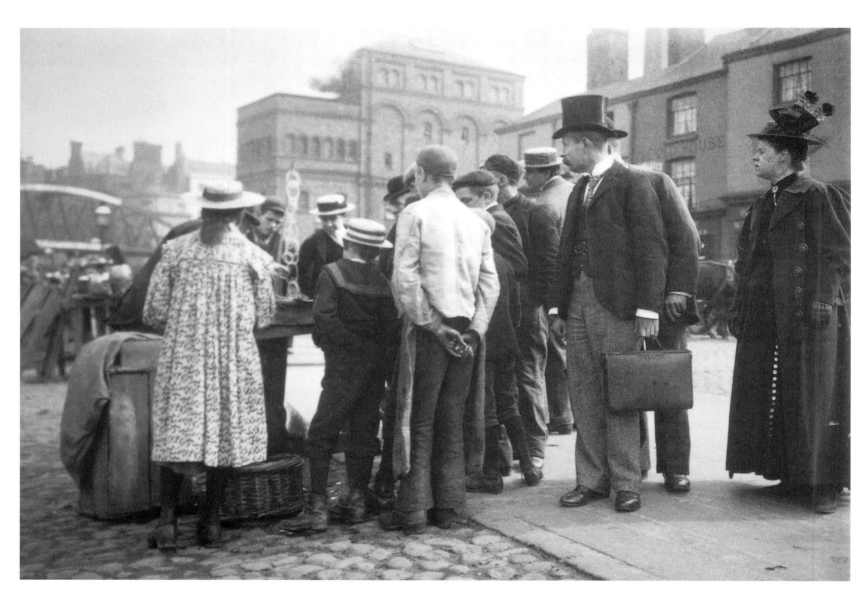

Street trader, Mann Island.

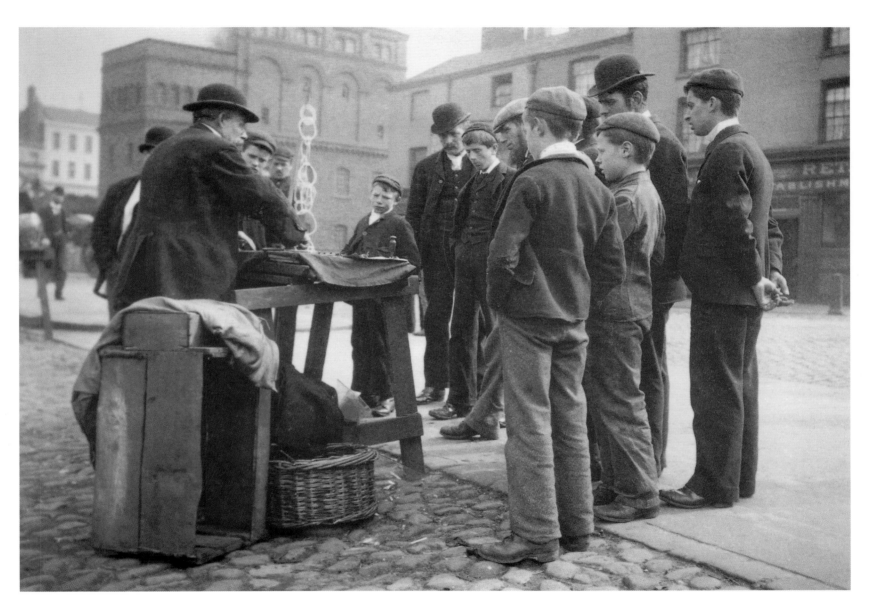

Street trader, Mann Island.

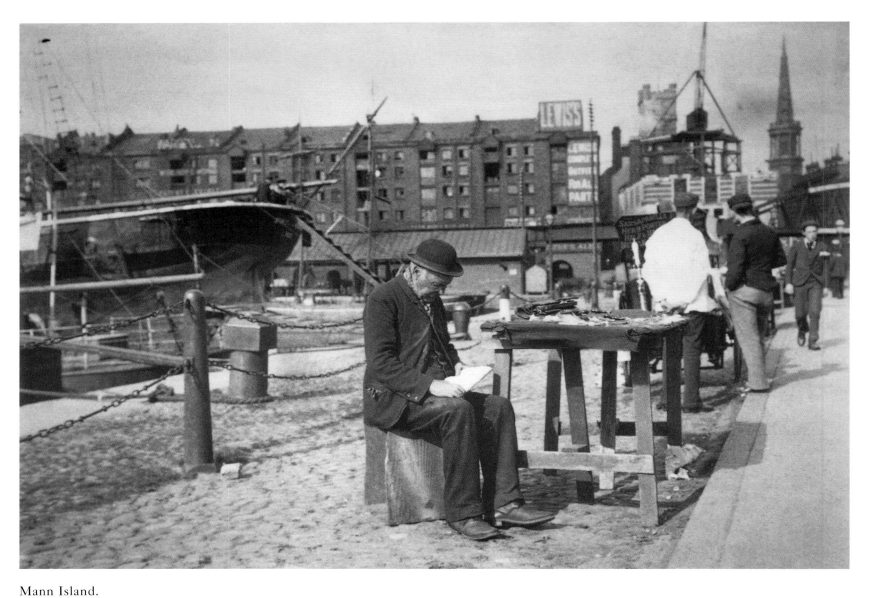

Mann Island.

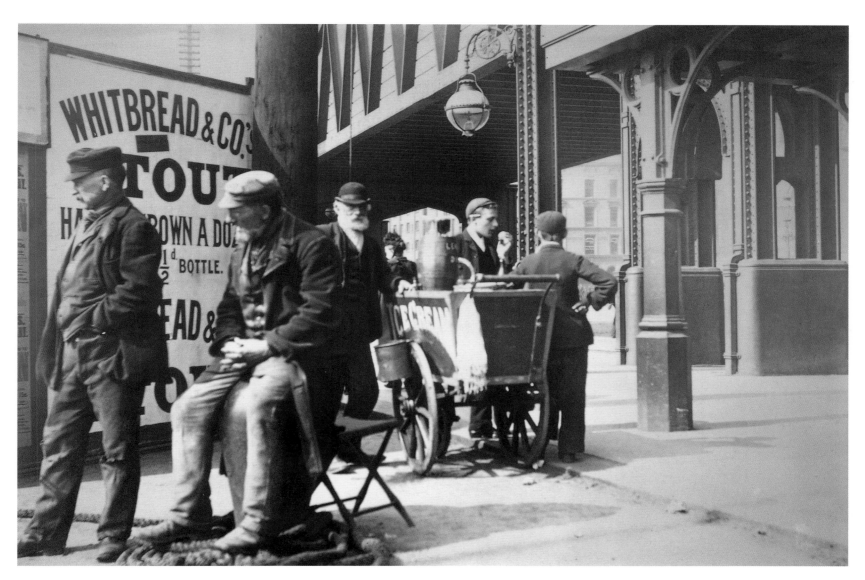

Ice-cream seller, Liverpool Overhead Railway station at Pier Head.

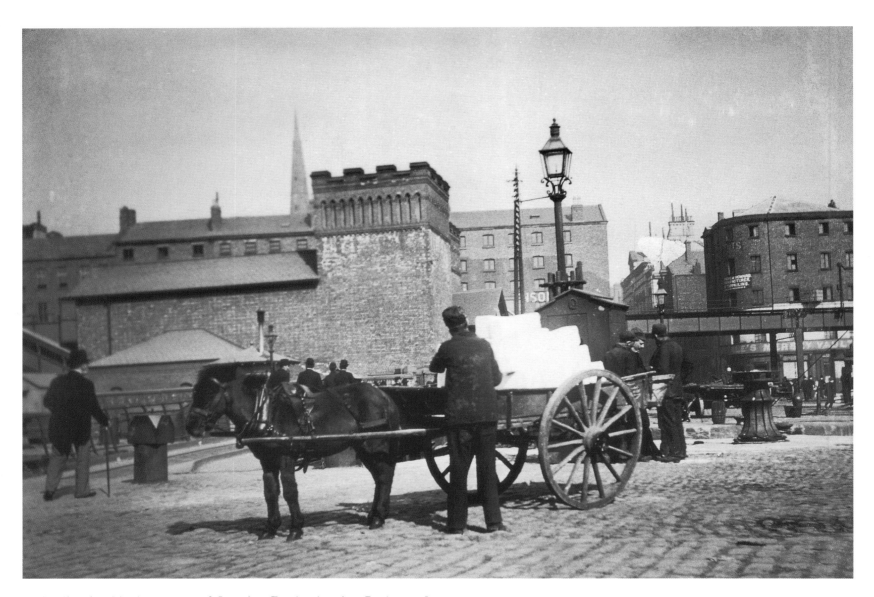

Unloading ice blocks, corner of Canning Dock, showing Redcross Street.

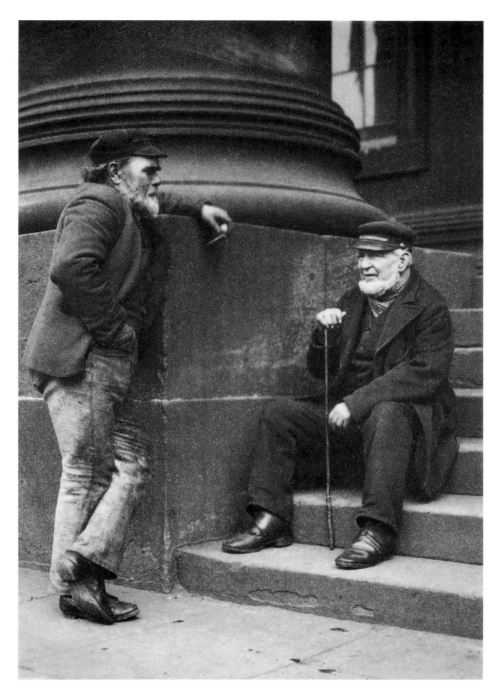

Outside Liverpool Custom House.

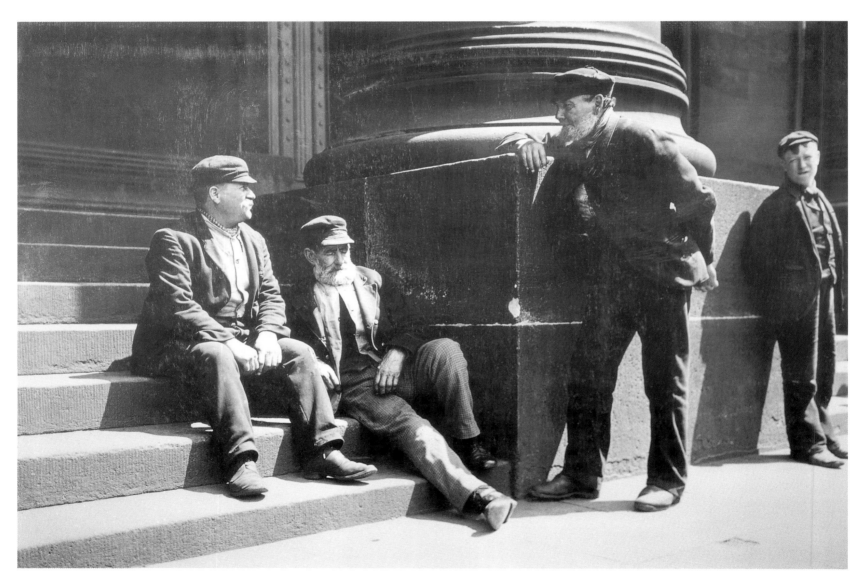

Outside Liverpool Custom House.

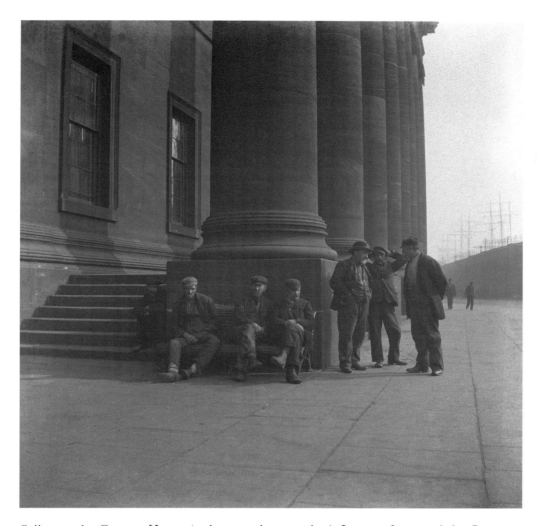

Sailors at the Custom House (unknown photographer). Inston often used the Custom House as a backdrop. His printing business on South John Street was literally round the corner and he could always guarantee a group of old sailors passing the time. This photograph indicates the appeal of the subject matter, although the unknown photographer has preferred a wider view, to give a stronger sense of location.

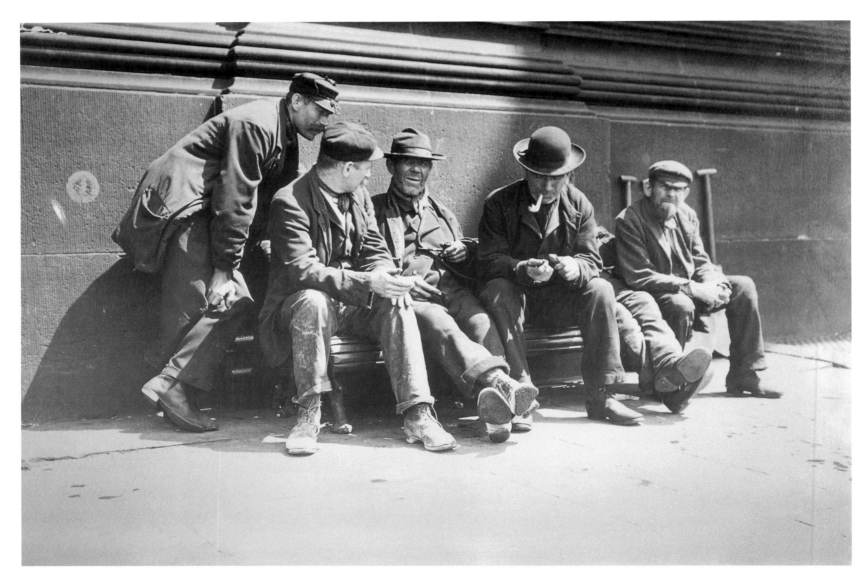

Labourers, Liverpool Custom House.

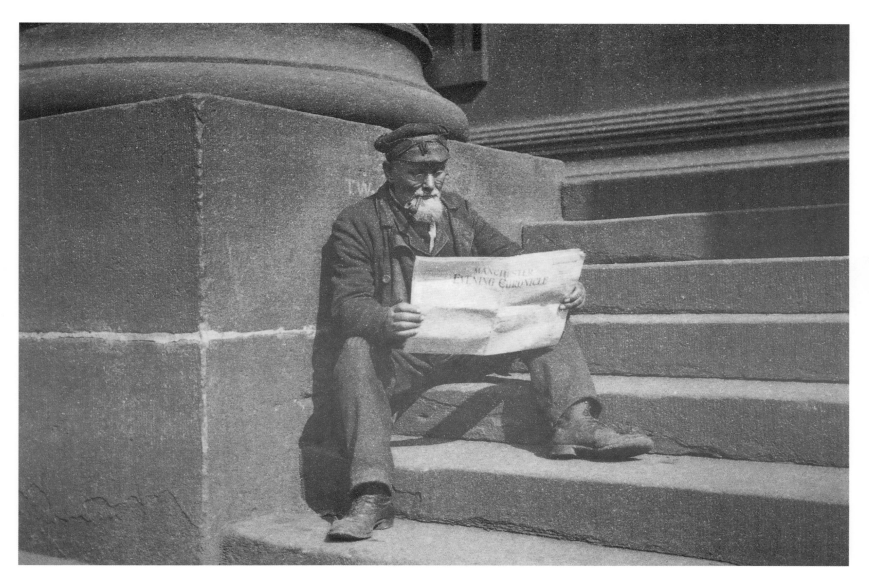

Reading the *Manchester Evening Chronicle* on the steps of the Custom House.

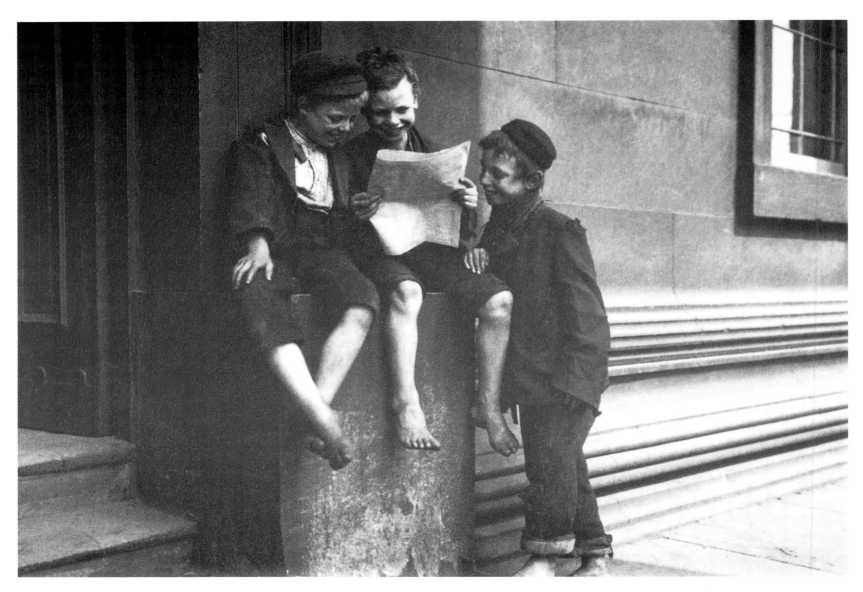

Boys reading outside the Custom House.

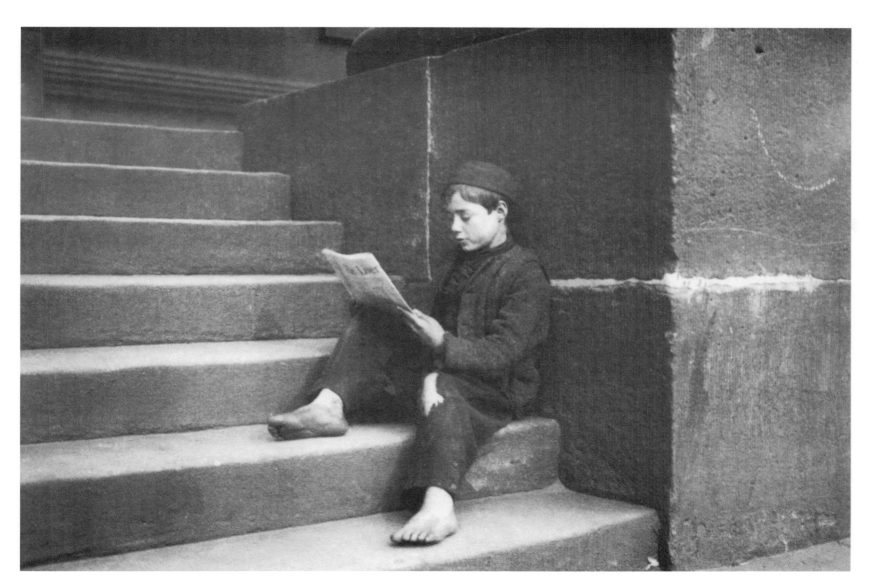

Boys reading the *Liverpool Echo* on the steps of the Custom House.

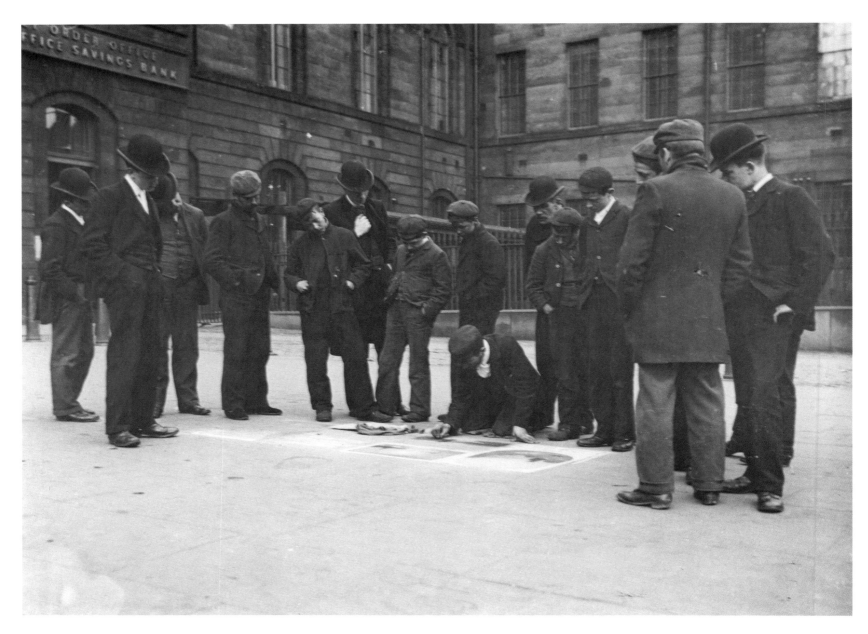

Pavement artist, Custom House.

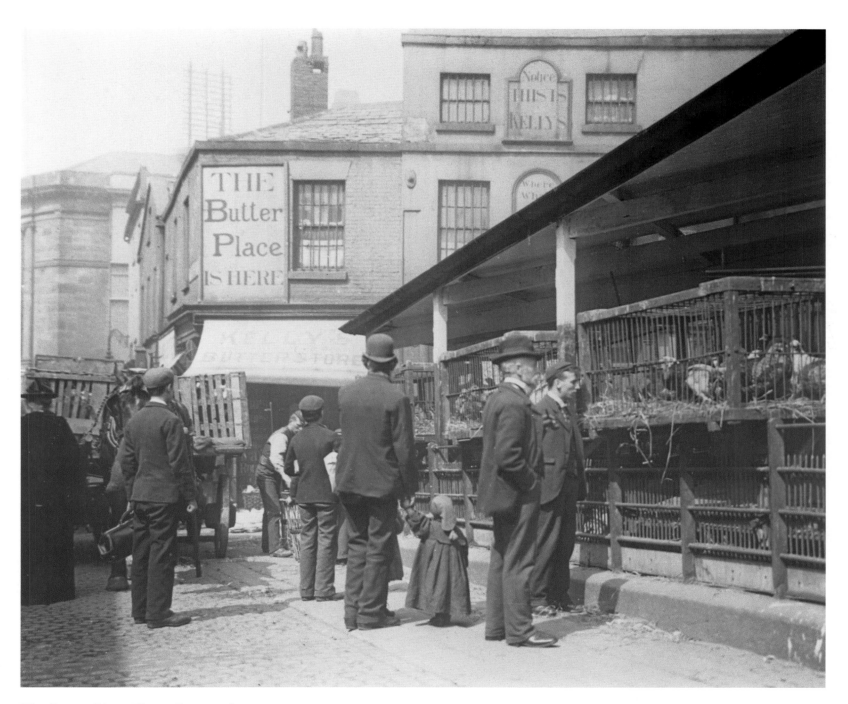

The Butter Place, Upper Dawson Street.

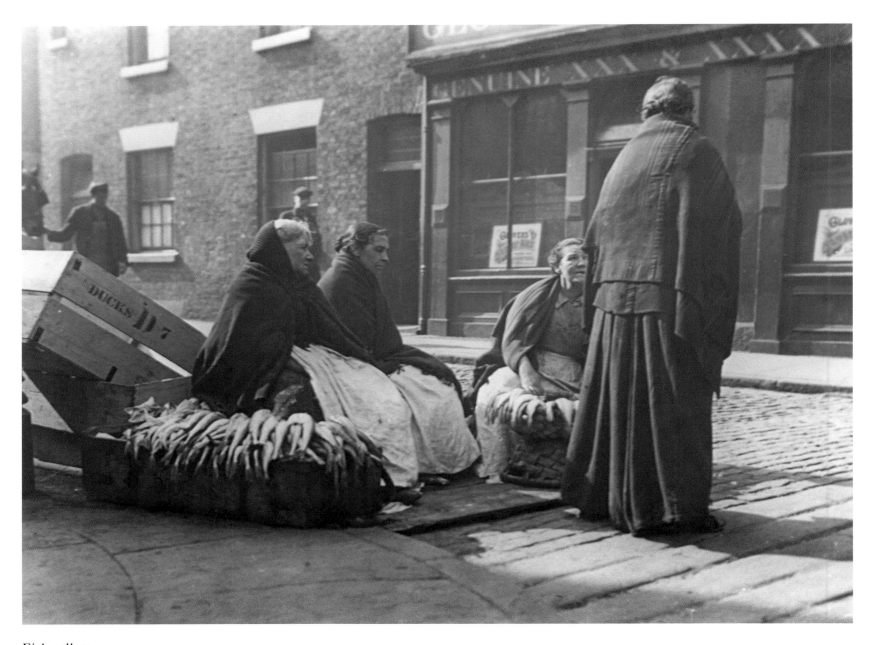

Fish sellers.

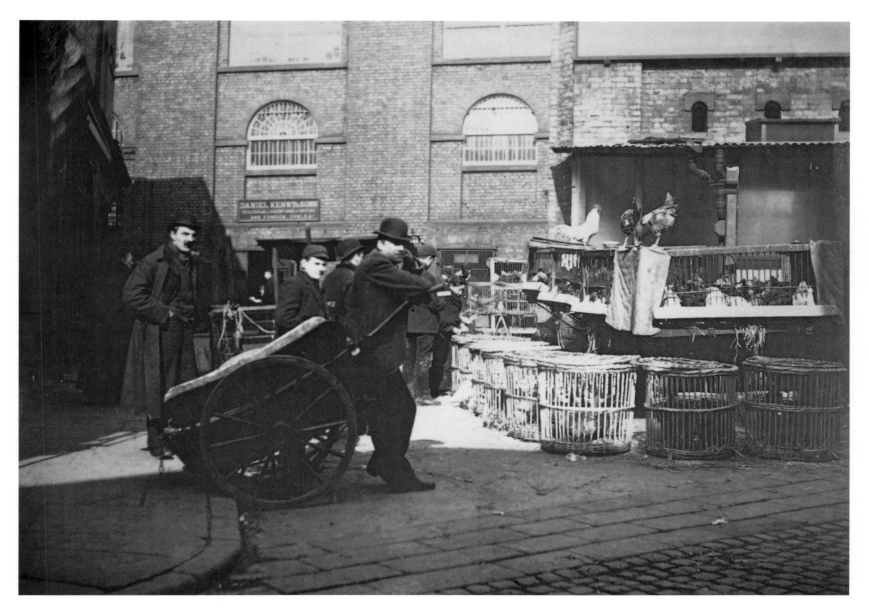

Back of St John's Market.

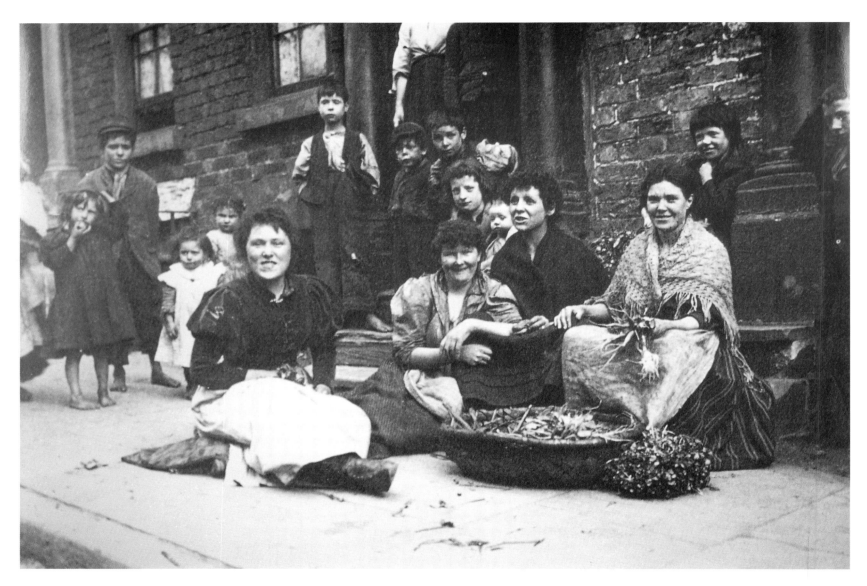

Back of St John's Market.

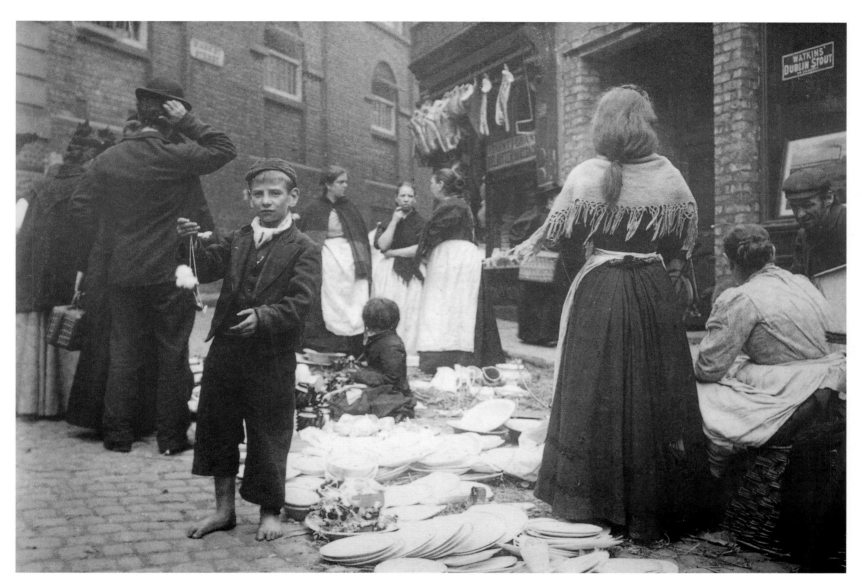

Back of St John's Market.

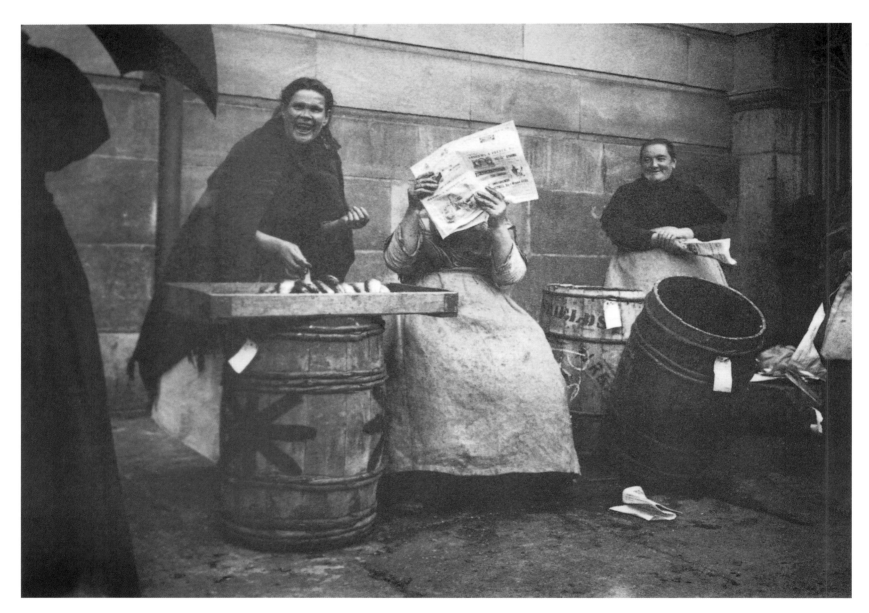

Outside the Fish Market, Great Charlotte Street.

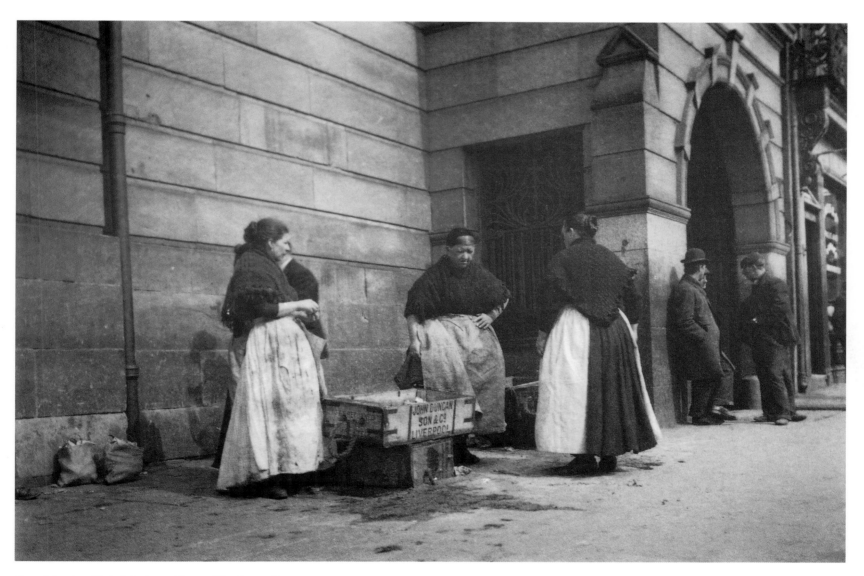

Outside the Fish Market, Great Charlotte Street.

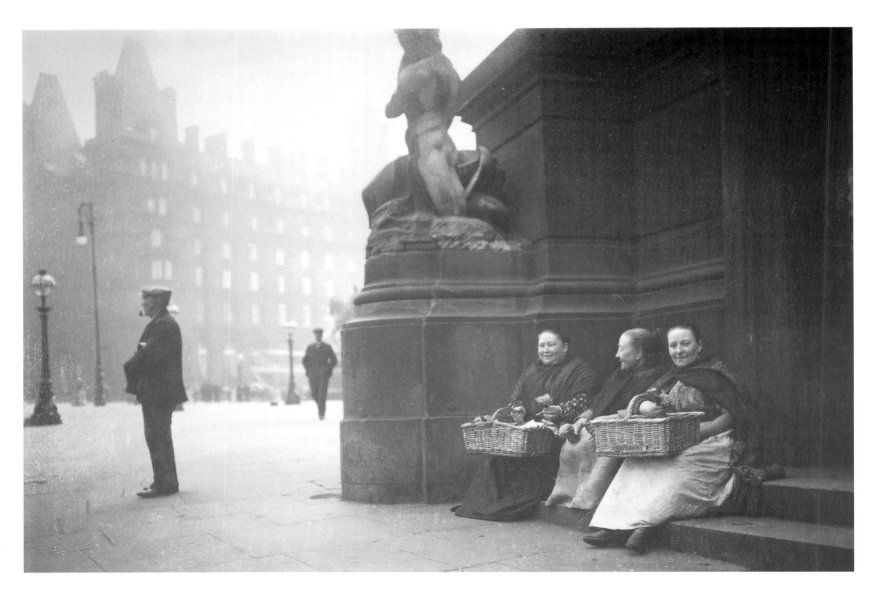

Street sellers on the steps of St George's Hall.

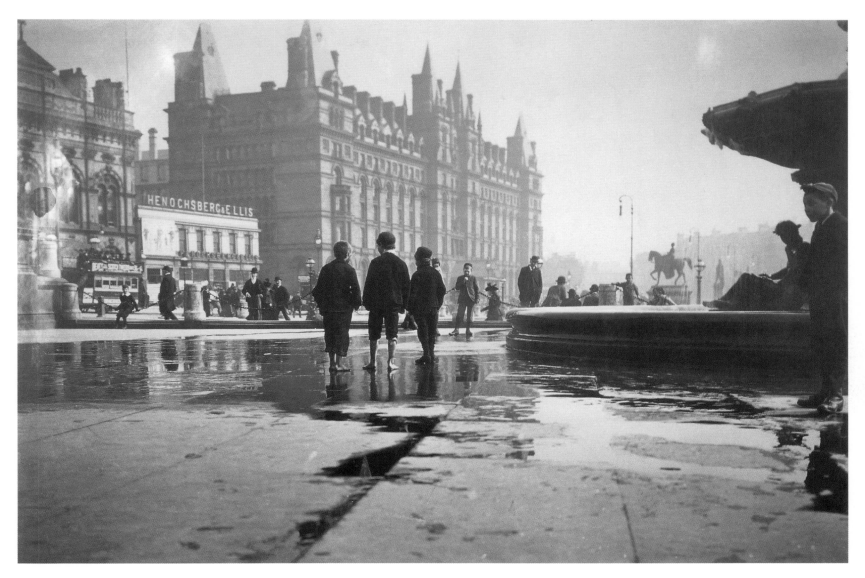

Lime Street.

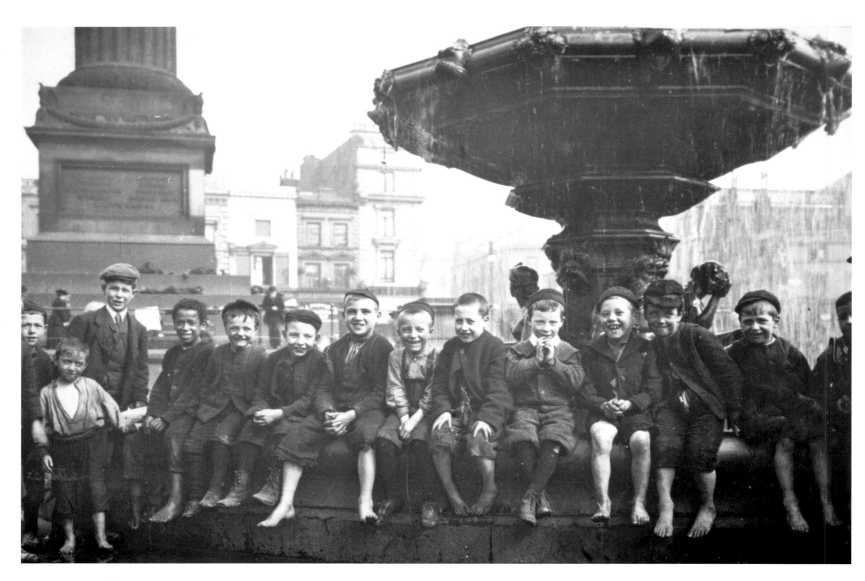

Street 'arabs', Steble fountain.

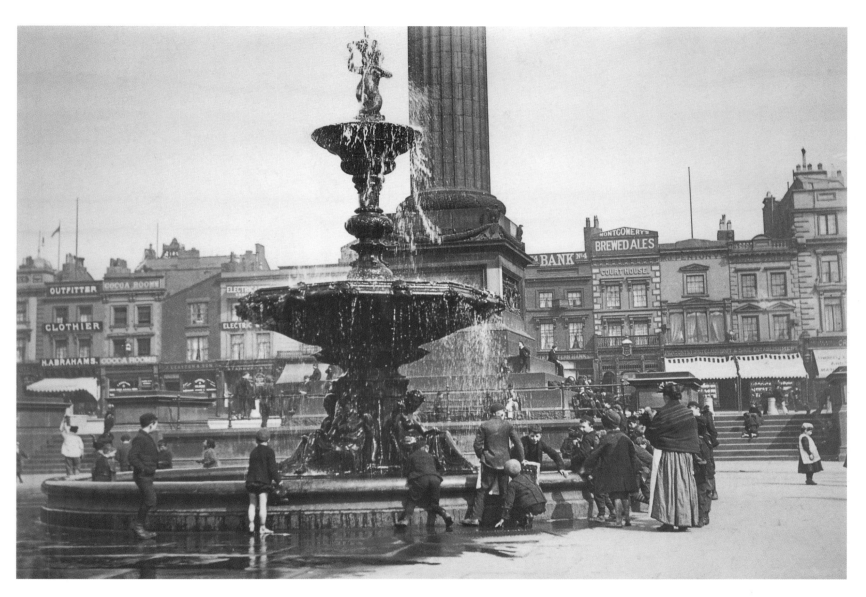

Steble fountain.

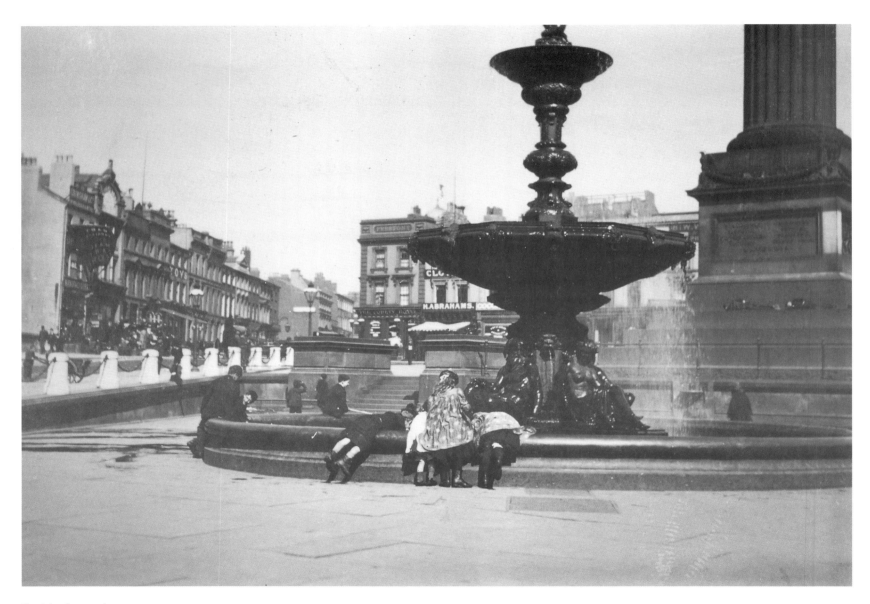

Steble fountain.

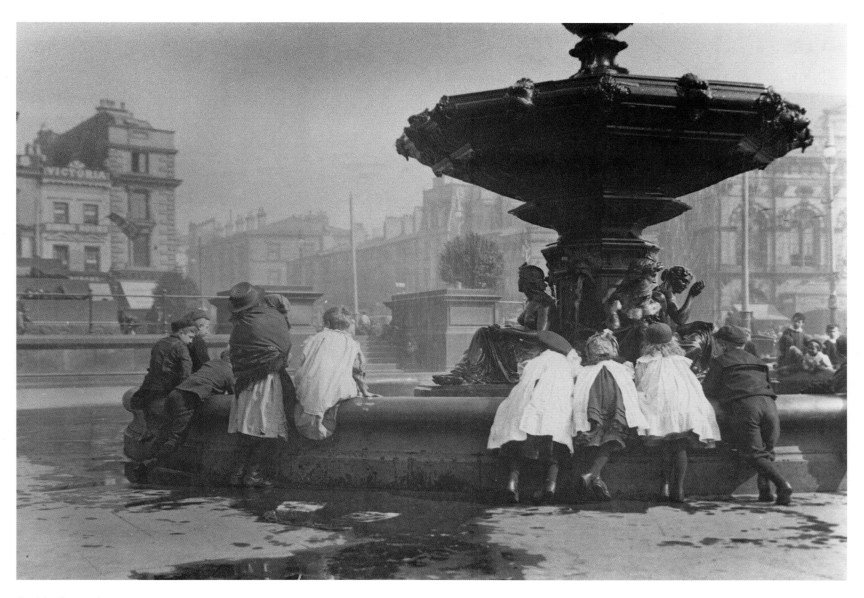

Steble fountain.

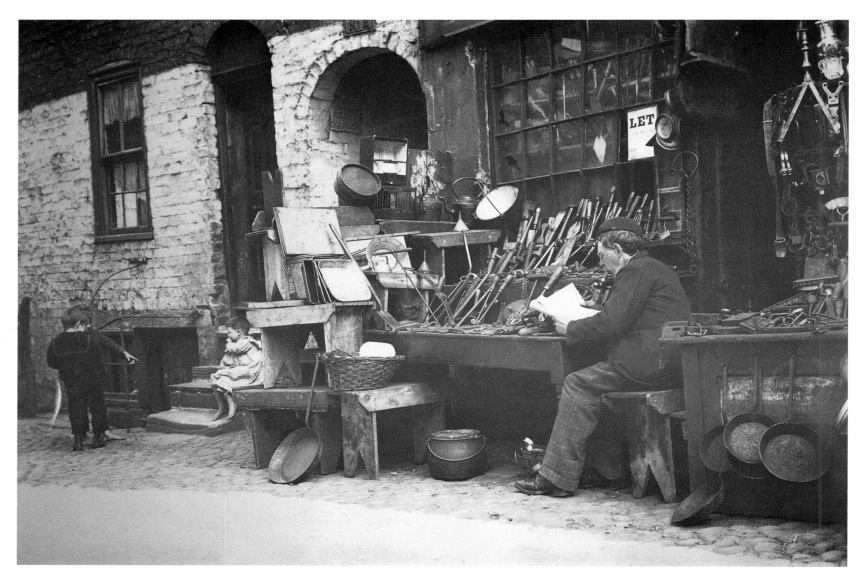

Owen Campbell's marine store, Athol Street.

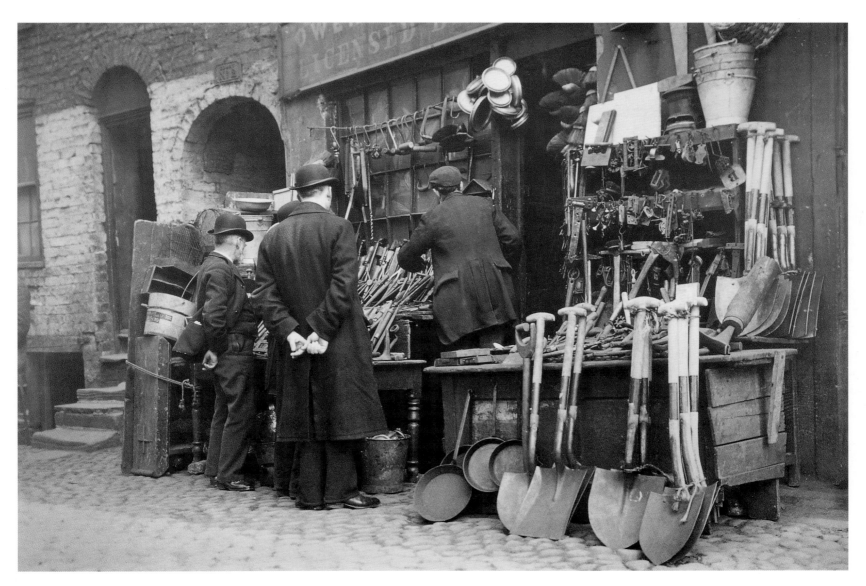

Owen Campbell's marine store, Athol Street.

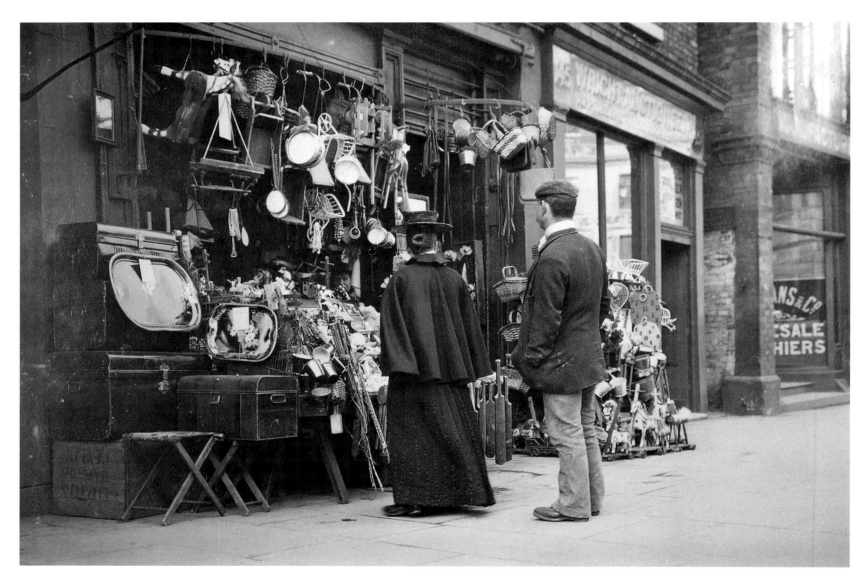

Dale Street, showing Parry's Toy Shop. Chorley Court (where
Robert Morris, signatory of the United States Declaration of
Independence, was born) is on the right.

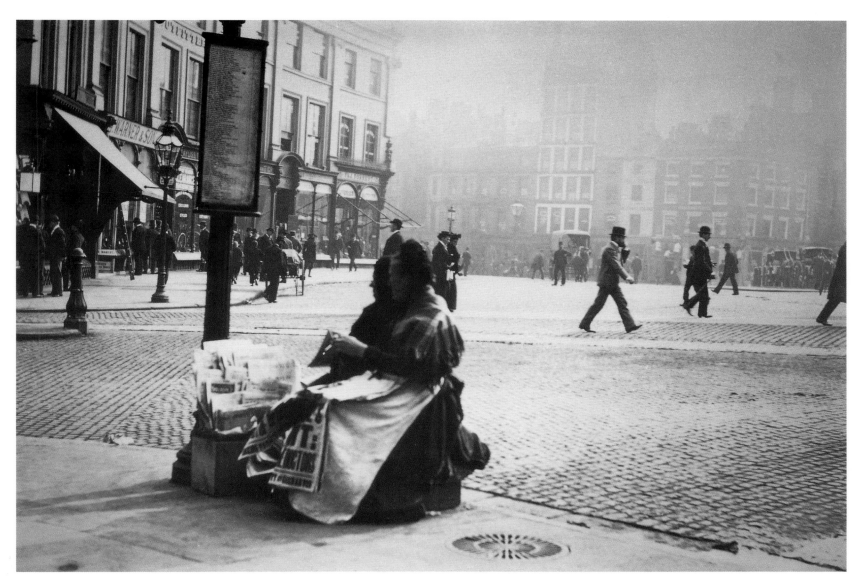

Newspaper seller, St. George's Crescent.

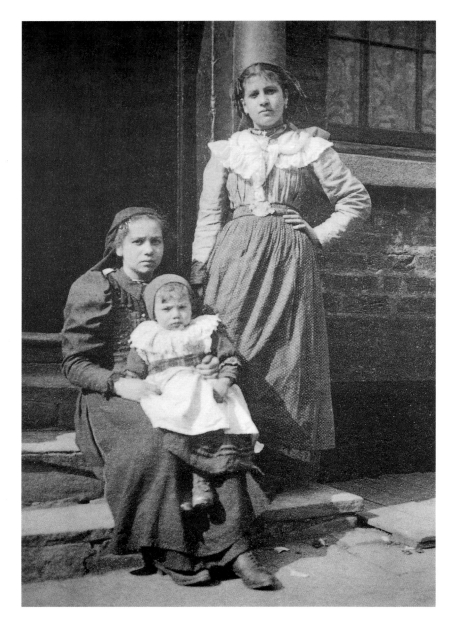
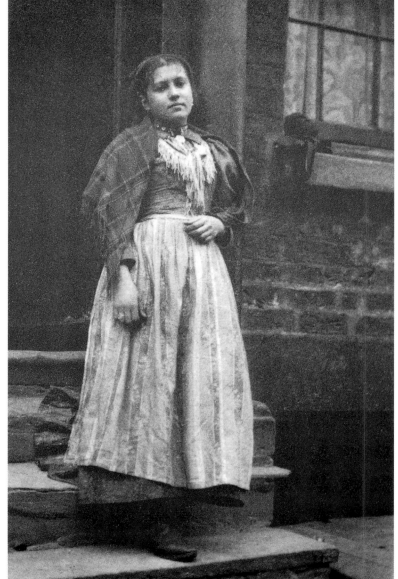

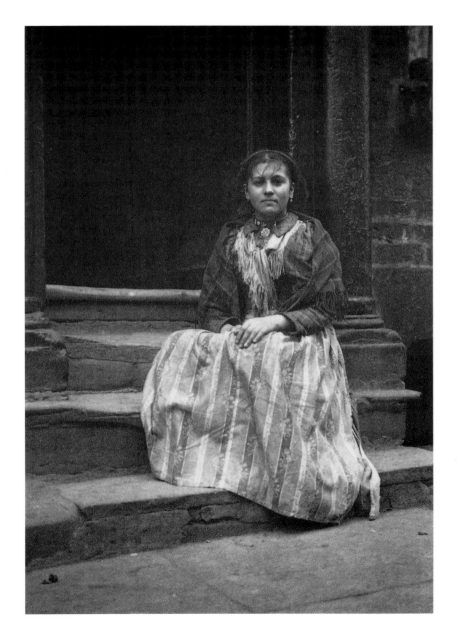

A young immigrant in national dress. Inston was obviously taken by the girl, photographing her in three separate poses, including a change of dress.

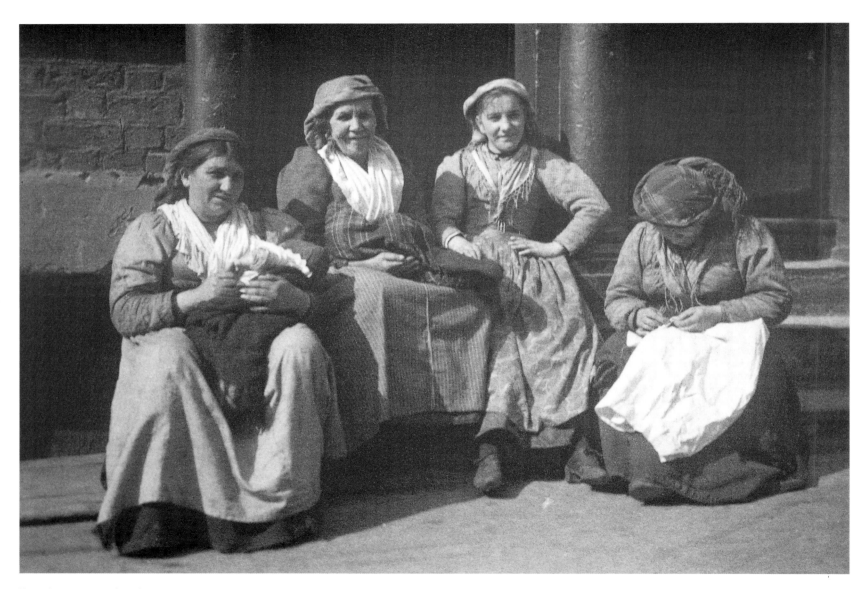

Immigrants sewing in the street.

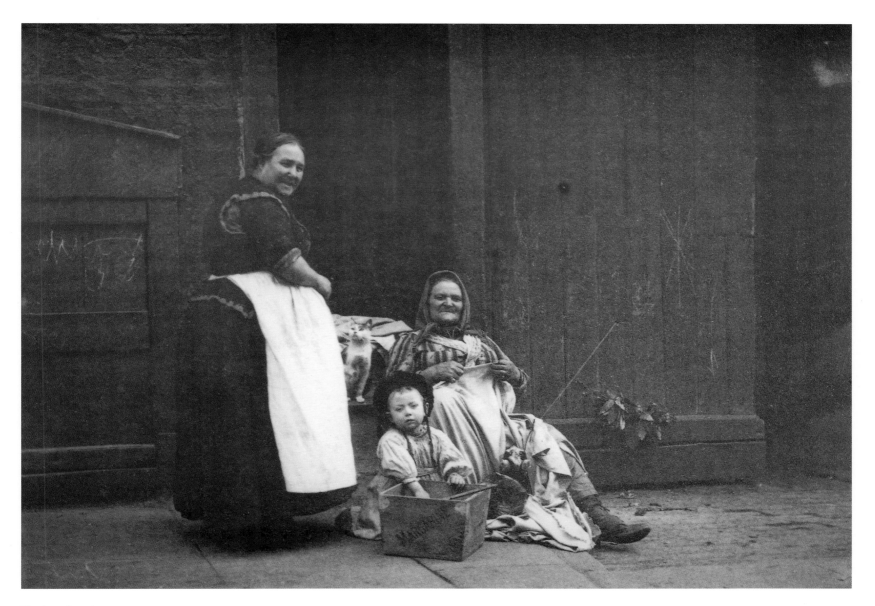

Posing for the camera.

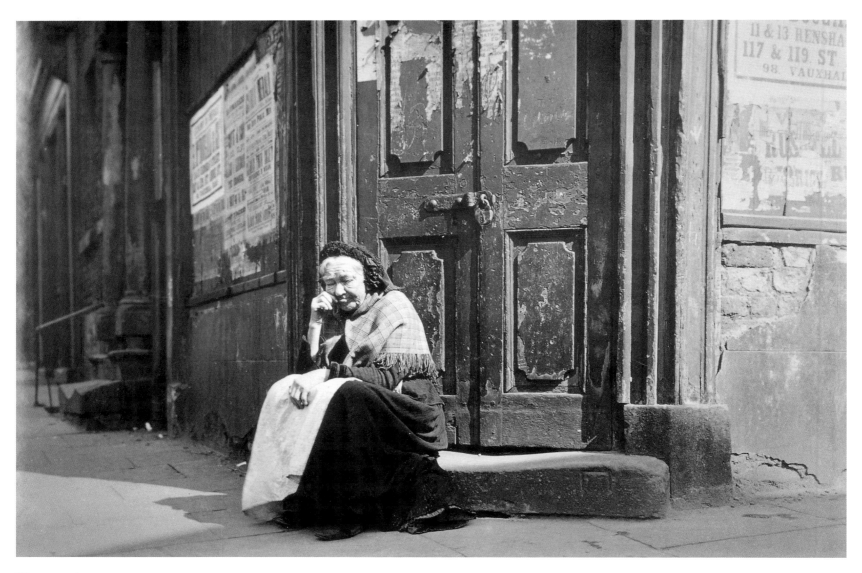

Weary and worn out.

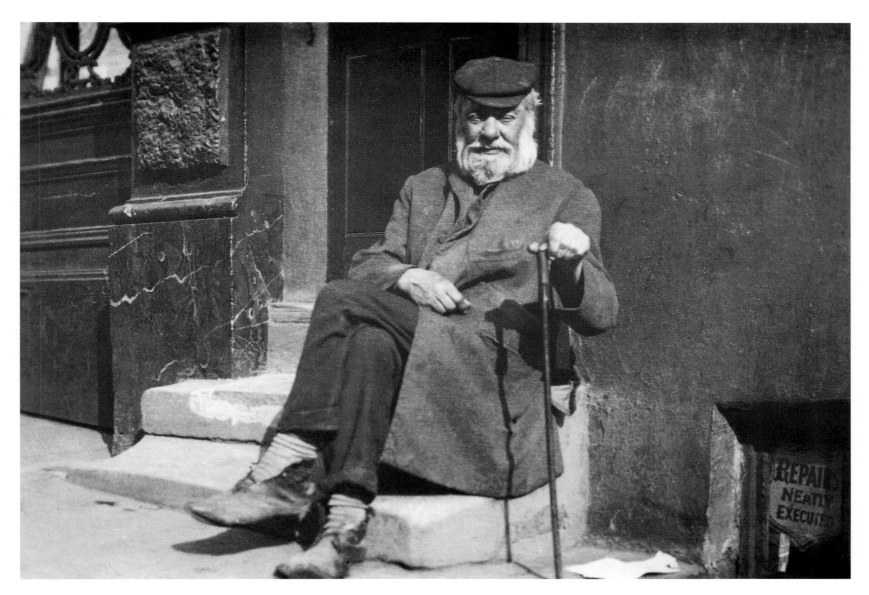

Repairs neatly executed.

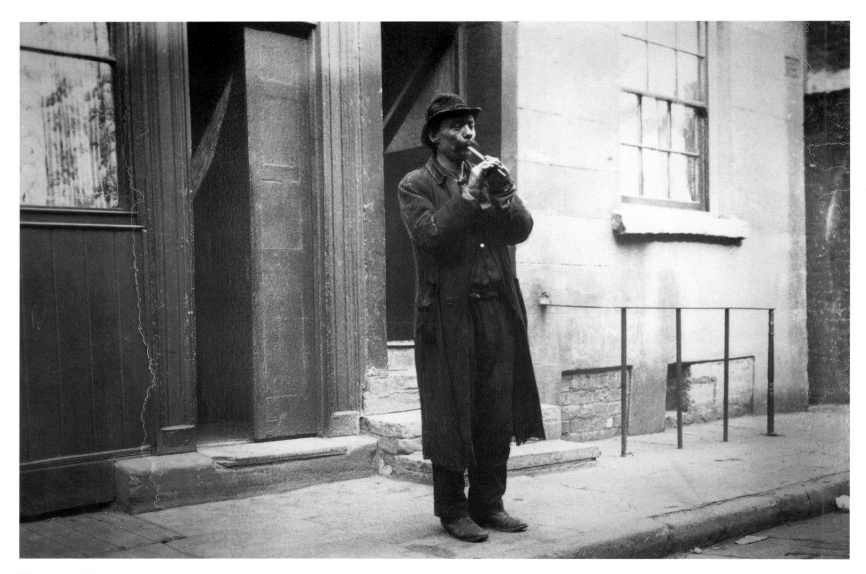

The tin whistle player.

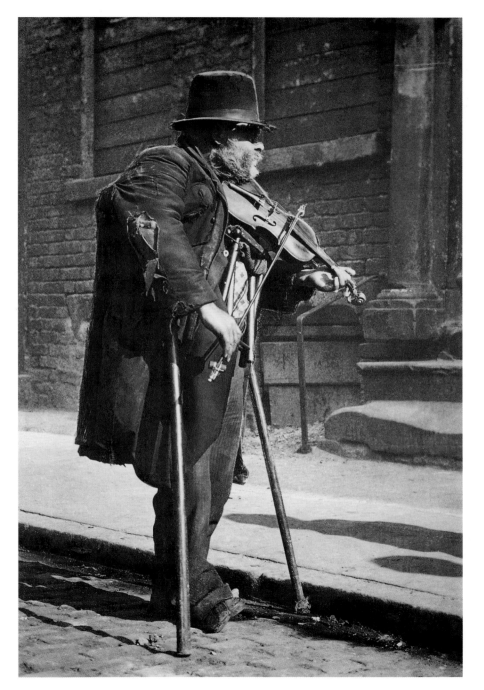

The old fiddler.

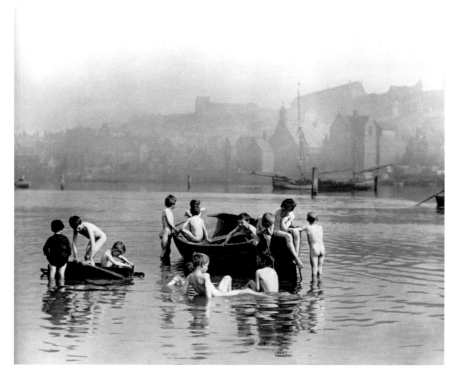

'The Water Rats' was Sutcliffe's most famous photograph. The Prince of Wales was so taken that he ordered a big enlargement to hang in Marlborough House. Others were less impressed and Sutcliffe was excommunicated by local clergy who thought the photograph indecent. Inston's studies of nude bathers have none of Sutcliffe's childhood innocence. The grim industrial setting, the underfed torsos and embarrassed awareness of the camera give his photographs an unintended poignancy and a sense of intrusion into the dark world of Liverpool's slums.

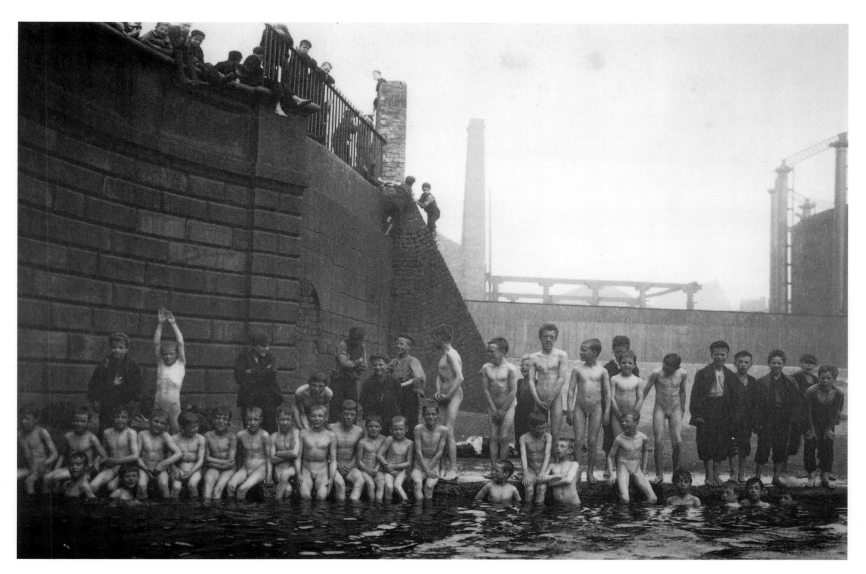

Bathers, Burlington Street Bridge.

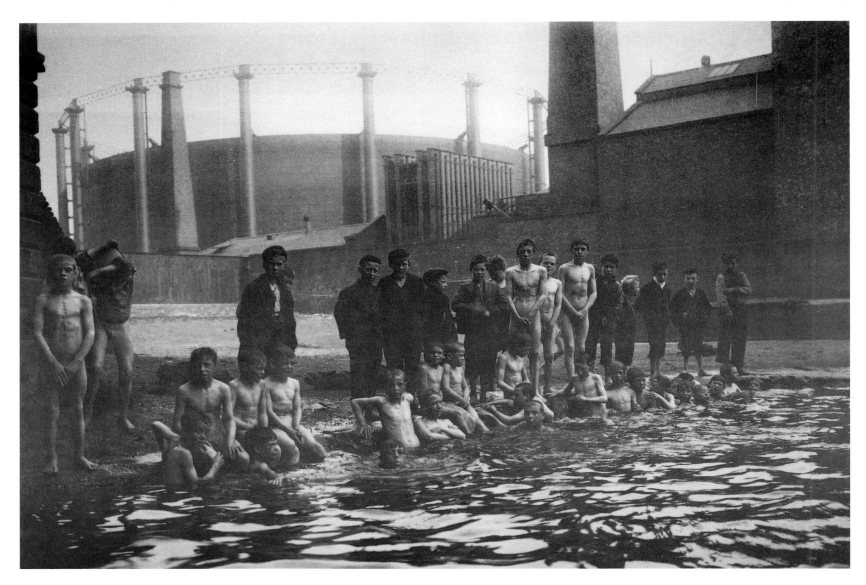

Bathers, Burlington Street Bridge.